THE SERIES

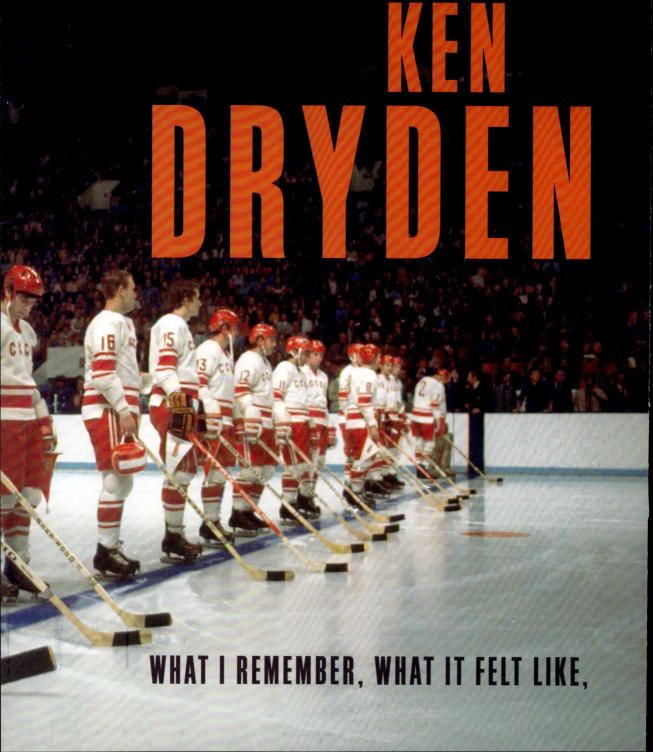

KEN
DRYDEN

WHAT I REMEMBER, WHAT IT FELT LIKE,

THE
SERIES

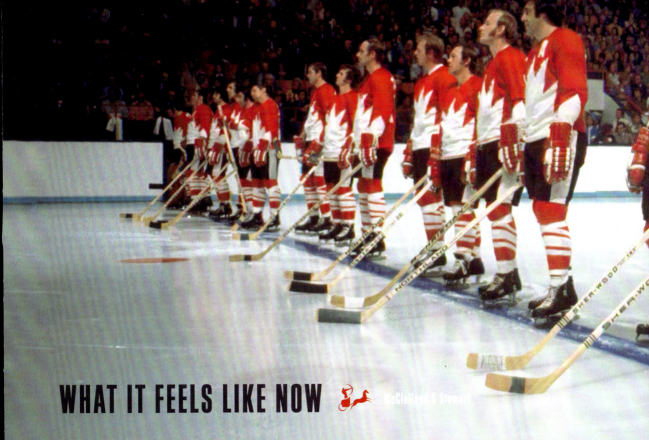

WHAT IT FEELS LIKE NOW

McClelland & Stewart

Library and Archives Canada Cataloguing in
Publication data is available upon request.

ISBN: 978-0-7710-0113-0
ebook ISBN: 978-0-7710-0114-7

Book design by Andrew Roberts
Jacket art: Melchior DiGiacomo / Getty Images
Typeset in Revival565 BT by M&S, Toronto
Printed in China

McClelland & Stewart,
a division of Penguin Random House Canada Limited,
a Penguin Random House Company

www.penguinrandomhouse.ca

1 2 3 4 5 26 25 24 23 22

Penguin
Random House
McCLELLAND & STEWART

TO

THE TEAM

Harry, John, Eddie, Gary, Pat, Bobby, Brad, Ron, Phil, Rod, Bill, Dennis, Vic, Yvan, Wayne, Red, Rod, Bill, Jean, Paul, Pete, Stan, J.P., Serge, Mickey, Guy, Don, Frank, Bobby, Ken, Dale, Gilbert, Marcel, Tony, Rick, Jocelyn, Brian

Three Thousand Canadians in Moscow

Twenty-two Million Canadians at Home

OUR OPPONENT

Vsevolod (Bobrov), Boris (Kulagin), Viktor (Zinger), Alexander (Gusev), Vladimir (Lutchenko), Viktor (Kuzkin), Alexander (Ragulin), Valeri (Vasiliev), Gennady (Tsygankov), Vyacheslav (Starshinov), Yuri (Blinov), Alexander (Maltsev). Yevgeni (Zimin), Yevgeni (Mishakov), Boris (Mikhailov), Yuri (Shatalov), Alexander (Yakushev), Vladimir (Petrov), Valeri (Kharlamov), Vladimir (Vikulov), Vladimir (Shadrin), Vladislav (Tretiak), Vyacheslav (Solodukhin), Vyacheslav (Anisin), Yuri (Lebedev), Alexander (Bodunov), Yuri (Liapkin), Yevgeni (Paladiev), Alexander (Sidelnikov), Alexander (Martynyuk), Alexander (Volchkov)

SCREAM

IT FELT LIKE A SCREAM. One long, out-of-control, never-not-there scream, from the opening puck drop in Montreal to the buzzer or horn or whatever it was that sounded the series' end that night in Moscow. Beginning even before that, from the day I got the phone call telling me I had been chosen for the team, and lasting to this day, fifty years later. Everything about the series a little bit bigger, its louds louder, its quiets quieter, its ups, downs, fears, fantasies, meanings. Everything.

This is not a chronicle. It's surely not accurate in every detail. This is what I remember. What it felt like. What it feels like now.

PART ONE

FACEOFF

WORLD CHAMPIONS
Penticton Vees, 1955
Vsevolod Bobrov, captain, later coach, 1972
George McAvoy, captain

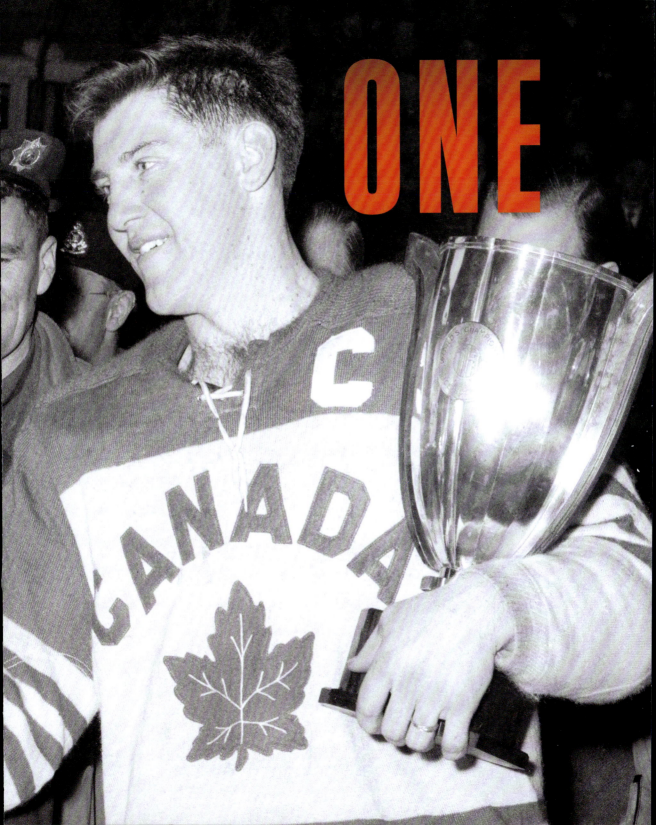

ONE

I REMEMBER being on a patch of pavement behind a portable at Humber Valley School in 1955. It was recess. A radio was on. I remember Foster Hewitt's voice. It was a game that mattered so much that he was there, in person, somewhere in Europe. The voice of the Toronto Maple Leafs, of hockey in English all across the country. It was Canada against Russia*, the final of the world hockey championship. Representing Canada, the Penticton Vees. I was in Etobicoke, Ontario. I didn't know where Penticton was. Until a few days earlier, I hadn't known the name of even one of its players. Now I knew the Warwick brothers, I knew Ivan McLelland, the goalie. I had hardly even known the name of the East York Lyndhursts, who, the year before, as Canada's team, had lost to the Russians. But I knew the score of that game: 7–2. I knew Canada was the best in the world, but I knew Russia was called the "world champion." And I knew we had to win this game. I was seven.

* From 1922 until 1991, the country was called the Soviet Union, its people the Soviets. Yet Canadians and Western media often used their pre-revolution names, Russia and Russians. I will use both interchangeably in the book.

SINDEN
4

ON THEIR WAY
Harry Sinden (top left) and
the 1958 Whitby Dunlops
Whitby Community Arena

ON TO
DUN

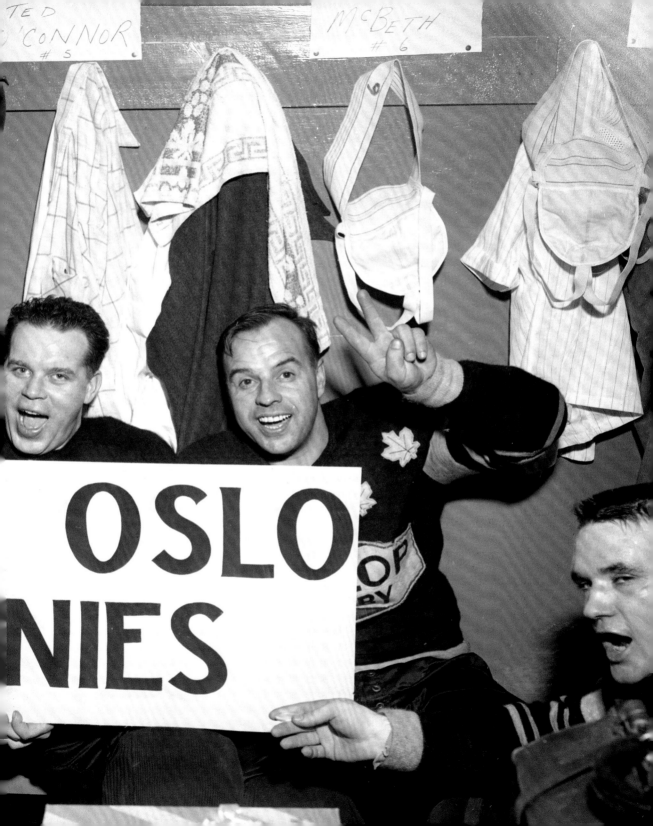

And we did win, 5–0.

I remember the Olympics the next year, in 1956, at Cortina. We were represented by the Kitchener-Waterloo Dutchmen— their initials, KWD, were my initials. And we lost.

We didn't play in the world championship the following year— the Soviet Union had invaded Hungary, and some countries, including Canada, boycotted the Games. But I remember the Whitby Dunlops the year after. Harry Sinden was their captain. I remember rushing home from practice the night they played the Russians in an exhibition game in Toronto. It was only November, the world championship was months away, but the game was so important it was on TV. So important it was played at Maple Leaf Gardens. So important I was crushed when the Russians scored two goals in the first few minutes. But then we scored, and scored again, and again, and we won, 7–2. I remember, too, later that season, in Europe, on an outdoor rink, with Foster Hewitt there again, in person, we won again. We were world champions.

The next year, 1959, it was the Belleville McFarlands, and then the Trail Smoke Eaters in 1961. World champions. And in between, at the 1960 Olympics in Squaw Valley, California, where we lost (the Kitchener-Waterloo Dutchmen again) and the Americans won—*the Americans!* Everyone knew they

weren't the best. *They* knew they weren't the best. There wasn't even one American in the National Hockey League at the time. Later, their Olympic hero, goalie Jack McCartan, would play only a few games with the New York Rangers, then disappear into the minors forever. But at least the Americans were only the *Olympic*, not the *world*, champions. It was the Russians we thought about. And a year later, Trail won.

Penticton, Whitby, Belleville, Trail: none of them were towns of more than twenty-five thousand people. But we knew their names. At the time, there were only two Canadian teams in the six-team NHL—the Montreal Canadiens and the Toronto Maple Leafs. But, for a few weeks in 1955, 1958, 1959, and 1961, the Penticton Vees, Whitby Dunlops, Belleville McFarlands, and Trail Smoke Eaters were the third-best-known teams in Canada.

But then we started losing. To the Swedes in 1962, when the Russians weren't there—this time they boycotted—and then year after year to the Russians. It was so frustrating. So infuriating. We had Gordie Howe, we had Bobby Hull, Frank Mahovlich, Stan Mikita, Glenn Hall. We were the best in the world, so *undeniably* the best. And everyone knew it— in Canada, in the United States, Sweden, Czechoslovakia, Finland, even in the Soviet Union—anywhere hockey was played. They *had* to know. *Surely* they knew. But we couldn't send our best players because they were professionals, and the

world championships and Olympics were only for amateurs. The Cold War was a time of words. A time of perceptions, propaganda, and persuasion. What was real was what we believed. And *they* were called world champions. What if the others *didn't* know?

I was 15 in 1963, when the Russians began their domination. And while every new year I—and we—were never not hopeful, we weren't going to win again. Not this way. Older amateur players on teams like Whitby or Trail, their NHL dreams behind them, now weren't good enough. Younger amateurs, straight from junior, their dreams still ahead, might be. The Canadian National Team was the vision of Father David Bauer, a Basilian priest who had coached the St. Michael's College School Majors to the Memorial Cup title—the championship of Canadian junior hockey. He would gather a group of good, promising players right out of junior who were willing to go on a mission together: to win world championships and Olympic gold medals. The best juniors, he knew, would still choose the NHL path, but this team would stay together and get better together. And it did. But the Swedes, Czechoslovaks, Finns, and Russians, teams also made up of good, promising players, stayed together, too. And their players, with no NHL path to distract them, were their countries' best. They got better faster than Canada could. Three times, Canada finished third, but the gap between the national team and Europe's best was

widening, not narrowing. Every year from 1963 to 1969, seven straight seasons, we were the best in the world, but *they*, the Russians, were the world champions.

I was on the last of these national teams.

I joined the team in March 1969, a few days after finishing my college career with Cornell. In Stockholm, we ended up a bad fourth in the double round-robin tournament, winning four games, two each against the U.S. and Finland, and losing six, two each against the Soviet Union, Czechoslovakia, and Sweden. In Stockholm, I also watched two games that, to this day, I remember as the most exciting I have ever seen.

On August 21, 1968, the Russians had invaded Czechoslovakia. That next March, in Stockholm, was the first time their two hockey teams had faced each other since that moment. Behind one net, a banner written in Czech read defiantly, "March is not August." I had never seen players so needing to win. The Czechoslovaks fought for every puck, then fought and fought more. They dove in front of every shot. They won, 2–0. A week later, the teams played again. Again the Czechoslovaks won, 4–3. When the game was over, their players kissed the ice, then put their ears against it. At home, I was later told, their countrymen did the same, listening together, to hear if the oil in the pipeline from Russia had been turned off. I saw a young Czechoslovak

"MARCH IS NOT AUGUST"
Czechoslovak Fans, 1969 World Championships, Stockholm

student in the stands with a cardboard sign hanging around his neck. On it, he had drawn a Czechoslovakian tank shooting on a Russian net. I still have the sign.

The national team would have one last gasp. Canada was scheduled to host the 1970 world championship. The final games would be in Winnipeg, to celebrate Manitoba's 100th anniversary as a province. This time, the IIHF, the International Ice Hockey Federation, allowed Canada to use some non-NHL professional players. I was signed over the summer—a lot was expected of me—but I arrived at training camp ten pounds overweight and never really caught up.

To begin the 1969–70 season, we played, and won, a late-summer tournament in Leningrad (St. Petersburg) against club teams, mostly from the Soviet Union and Finland. The Red Army team, whose players made up the vast majority of the Russian national team, was not among them. Later that fall, we played games in Czechoslovakia and Finland, and in the Izvestia tournament in Moscow against many of the best European national teams, including the Soviet Union and its Red Army stars, and finished second. We played touring Russian and Czechoslovak teams in Canada. I remember one night in Victoria, losing to the Russians, 9–3. I allowed all nine goals. But our team was good enough to be hopeful. We would be playing at home. We had a chance.

Then, suddenly, everything was over. The deal that would allow Canada to use non-NHL pros was either reversed or had never been finalized, depending on whose version of the story is told. In any event, just before Christmas 1969, Canada withdrew from the world championship—and *all* international hockey competitions. The Canadian National Team was dead.

Since the first ever hockey game, played at the Victoria Skating Rink in Montreal in 1875, for ninety-four straight years, Canada had been the best in the world. But for the eighth and ninth consecutive years, in 1970 and 1971, the Russians were the world champions. There was no end in sight.

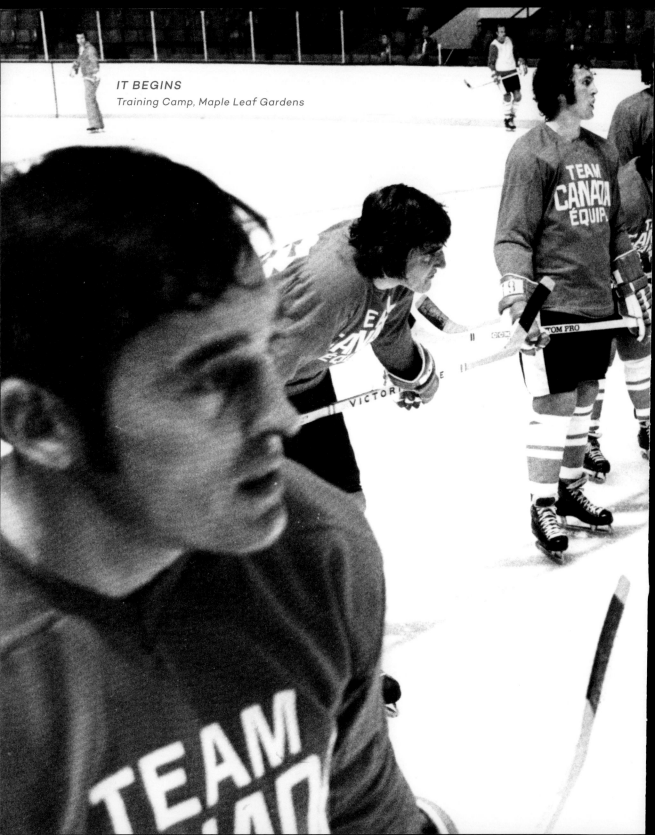

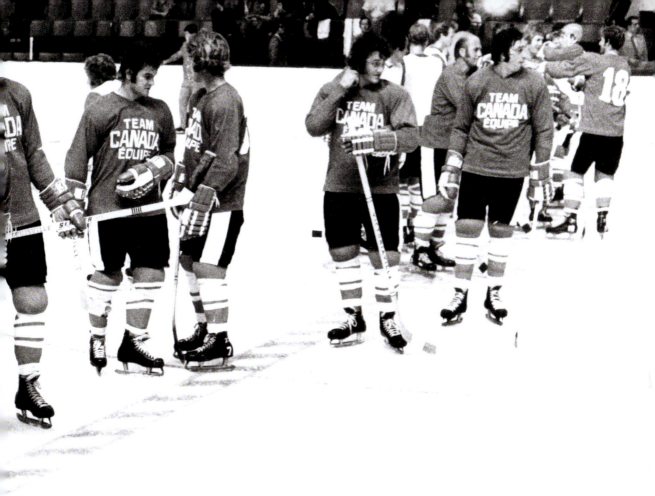

TWO

PHIL ESPOSITO and the Russian captain, whoever it was, stood at centre ice, bent at the waist, facing each other, their eyes cast down. Near them were some photographers, other dignitaries, and Prime Minister Pierre Trudeau. Trudeau smiled his big public-occasion smile, but it looked different. Everything was different.

I had played in the Montreal Forum maybe forty times, through one season of home games and two playoff years, the building always full, always loud, excited, and ready. Especially for the big games, especially in the Stanley Cup playoffs, especially in the finals, especially when down two games to none and we had to win and everyone, the fans and us together, knew it. Especially when down three games to two in the finals and there was no option left but to win. But this night was different.

The buildup to this moment had snuck up on us. From the call I got from Harry Sinden—captain of the 1958 world champion

NHLPA

NATIONAL HOCKEY LEAGUE PLAYERS' ASSOCIATION

45 Richmond Street West, Suite 705, Toronto, Canada, (416)366-5375

May 20, 1972

Dear N.H.L.P.A. Member:

You are hereby notified that you have been chosen to represent Canada against Russia in the September series.

You will be obliged to attend a training camp in Toronto commencing August 20th. The games will probably take place in Canada on September 2, 4, 6, and 8.

You will be paid a salary of $200.00 per week for each week of training plus the sum of $100.00 for each game in which you play.

In addition, the N.H.L. Players' pension fund will receive thousands of dollars which will be of ultimate benefit to every player in the N.H.L.

As you can appreciate, time is of the essence and your early co-operation is requested.

If you cannot participate for any reason, would you please advise us as soon as possible.

Many thanks,

R. Alan Eagleson
Executive Director

Whitby Dunlops, coach of the 1970 Stanley Cup–winning Boston Bruins, now coach of Team Canada 1972—telling me I was on the team, to the days that followed, everything summer-normal, summer-gradual. Then the occasional bursts of newspaper stories in June and July. Then the talk on the street, not a buzz, but more than usual. My summer routines—a little running, a little tennis—but more than other years. And less ice cream. Something was in the air. Time moving a little faster, training camp beginning a month earlier, me waking up each day with a little more urgency in my stomach.

Then, suddenly, we were in Toronto, in Maple Leaf Gardens, in *Team Canada Équipe* practice jerseys. All the reporters, the cameramen. A coach and most of the players I didn't know and who didn't know me. Then, almost as suddenly, things settled into the almost familiar. The dressing room, the laughing, the chirping, the guys who'd put on a few summer pounds and who, after a few up-and-backs, looked like they were going to die. The little injuries that set you behind a day or two when you didn't have a day to lose. But we'd done this before. We knew how to do it. We'd get into a little better shape each day, physical shape, competitive shape, each of us at the same pace. Then we'd begin to get better, the team would come together, and when it was time, we knew we'd be ready.

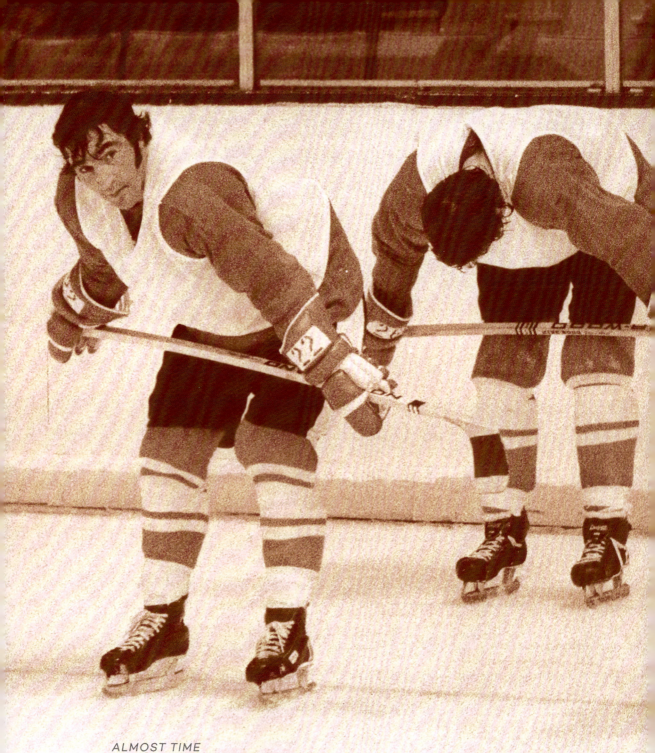

ALMOST TIME
Toronto
(L to R): J.P. Parisé, Don Awrey, Bill White

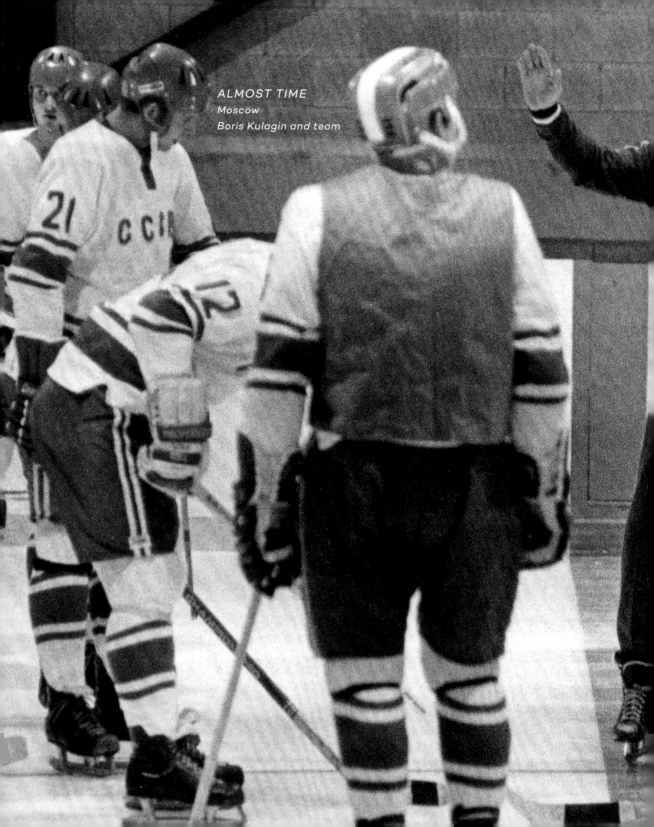

ALMOST TIME
Moscow
Boris Kulagin and team

All of Canada's best players were there, except Bobby Orr, who was injured, and Bobby Hull, who had signed with the Winnipeg Jets of the NHL rival World Hockey Association. All of the NHL's top scorers, the top goalies, every member of the league's first and second all-star teams, except Orr—thirty-five of us. In scrimmages and intra-squad games, the two best teams in the world were on that ice at Maple Leaf Gardens. That's what the reporters said, and no one argued. The biggest question, it seemed: When the games begin, which twenty will play? And which fully deserving fifteen will not? Another question, not talked about, that each day became more intriguing: When stars are playing with stars, and stars are up against stars, who emerges as the *real* stars? Who shrinks and fades? Who are the best of the best? On a team of captains, who are its leaders? Only each day's test would tell, and only the players would know. In the early practices, some stars were playing better than any of us expected, some were not, but it didn't matter much—there was time. That's what training camp is for.

The Russians were in Moscow at their training camp, but we didn't think about them much, and only when we were asked. We were getting *ourselves* ready. We were doing what we could do, and that was all that was needed. We were the best in the world. This wasn't arrogance. This was truth. When we were asked about the Russians, we said what we knew: they're good. They've won all these world championships, so

they have to be good. They're great passers, they don't shoot a lot, their goaltending isn't very good—it never is. But they're in great shape. We need to be ready. We need only to play the way we play, the way the best in the world play. It doesn't matter how anyone else plays. If it did matter, they'd be the best. And our practices are good. We're doing fine.

Rod Seiling had played against the Russians with the national team, Red Berenson with the Belleville McFarlands, and a few others against touring Russian teams as juniors. And when I said the Russians were good, I knew they were—I'd lost, 9–3, in Victoria! Some of the others might have known, too. But the Russians had only been good against the national team and junior teams, few of whose players ever played a minute in the NHL. This was *Team Canada*. These were NHL stars, the best in the world. So, I knew, but really I only *kind of* knew.

Then the pace picked up again. The games that had always been forever away were suddenly right here.

And right there and everywhere, always, was Alan Eagleson. Eagleson was the head of the NHL Players' Association, still in its early stages, and hockey's biggest agent. The series might have been years in the dreaming, but it was only a very short time in the planning. Who would make up the team? How would it be chosen? What about the coaches? Where

would it be played? What about training camp? What about the referees, the broadcasters, the corporate sponsors? Who would pay for this? What would the team even be called—the NHL All-Stars? Canada? What jerseys would we wear? And who would negotiate all this? The NHL? Once they couldn't stop it, they didn't want anything to do with this series. The Canadian government? They didn't do stuff like this, not directly; and, they would take forever. Hockey Canada? A creation of the federal government, it was only a fledgling organization at the time, yet if the IIHF had to be involved because this was an international series, then Hockey Canada, as the country's official international representative, also had to be. But who had the trust of the NHL, the team owners, the players? Certainly not Hockey Canada. And while Eagleson might not have had everybody's complete trust, who could get the paperwork agreed to and done? Who had his finger in almost every pie? Eagleson. He was the one the players knew. He was the one we went to: "Hey, Al, what about our hotel rooms?" "Hey, Al, what about tickets?" "Hey, Al, what about our wives?" He talked louder, laughed louder, got in the first word to put you on your heels and the last one to keep you there. He loved the action and being at the centre of it. And he was a total partisan. You were on *his* side, or you were the enemy. And in the few days that now remained, he was even more everywhere.

To show us what the Russians looked like, Sinden dusted off a film of the 1958 world championship he had won with Whitby. The film was in black and white, the game was outdoors, some of the Russian players wore toques. It looked like the Middle Ages. And if we saw anything in the film other than that, it was that a bunch of Canadian players we didn't know, whose names weren't Maurice Richard, Gordie Howe, Jean Béliveau, Doug Harvey, or Jacques Plante, had beaten the Russians. After the laughter wouldn't subside—"Hey, Harry, did you trip over the blue line?"—Sinden shut it down. We had seen on that screen what we already knew. More and more stories filled the sports pages. The reporters yelled out their predictions. They, too, told us what we already knew— this would be a dominant, smashing, defining victory for Canada, likely eight straight. Talk on the street, every street in the country, turned to a loud buzz.

At some point, probably the day before the first game, Harry told me I would play, but I don't remember. I don't remember flying to Montreal. I don't remember the day of the game. I don't remember the dressing room. All I remember is a *feeling* that kept building and building, growing and growing. It's what happens before a Stanley Cup series, before a Stanley Cup final, but not like this. It built to where it couldn't build anymore, grew to where it had no place left to grow, then it built and grew some more. That night in the Forum, there in living

rooms in front of TVs everywhere in Canada, there inside us, there was something that had been decades in the making. Year after year after year after year. We had created this game, we were the best players in the world, but *they*, not we, were called world champions.

No more!

The Forum was in full frenzy. Even Prime Minister Trudeau, the man who had generated "Trudeaumania" a few years earlier, who had delivered raise-the-roof speeches before thousands at political rallies, looked astonished. Stunned. This was like nothing he, or any of us, had ever heard or felt before. Phil Esposito, the league's great goal scorer, thirty years old, veteran of more than six hundred NHL games, positioned himself for the ceremonial faceoff at centre ice. A ritual moment, nothing more: the honoured person—in this case, Trudeau—dropping the puck; the captain of the home team—in this case, Esposito— moving his stick gently forward, then, with the puck on his stick, gently back, his opponent remaining motionless, then Esposito, as the home team captain, picking up the puck and handing it to the honouree. Instead, Esposito flashed his stick forward, whipped the puck back to his teammates and raised his arm in triumph. "I had to win that draw," he said later. This was not a ceremonial faceoff. This was a *symbolic* faceoff.

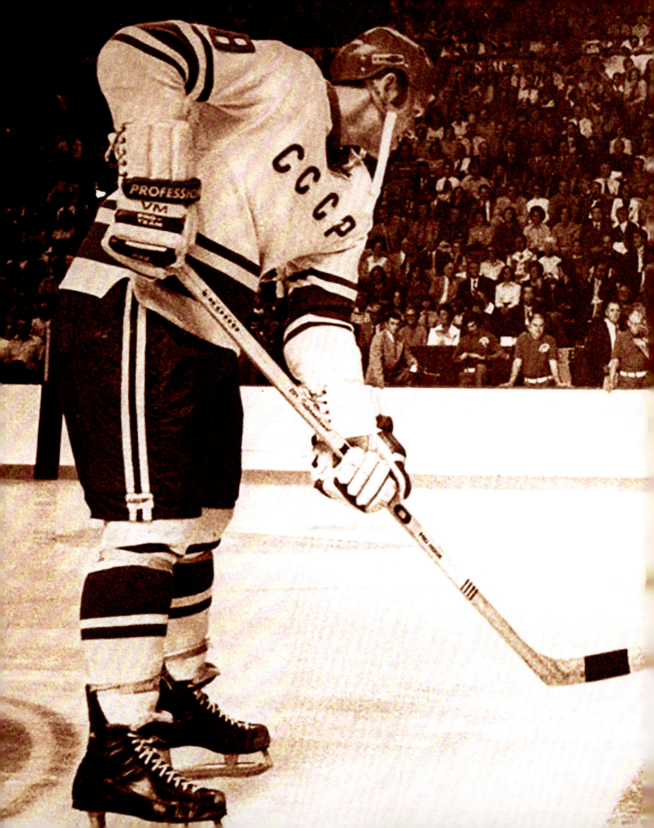

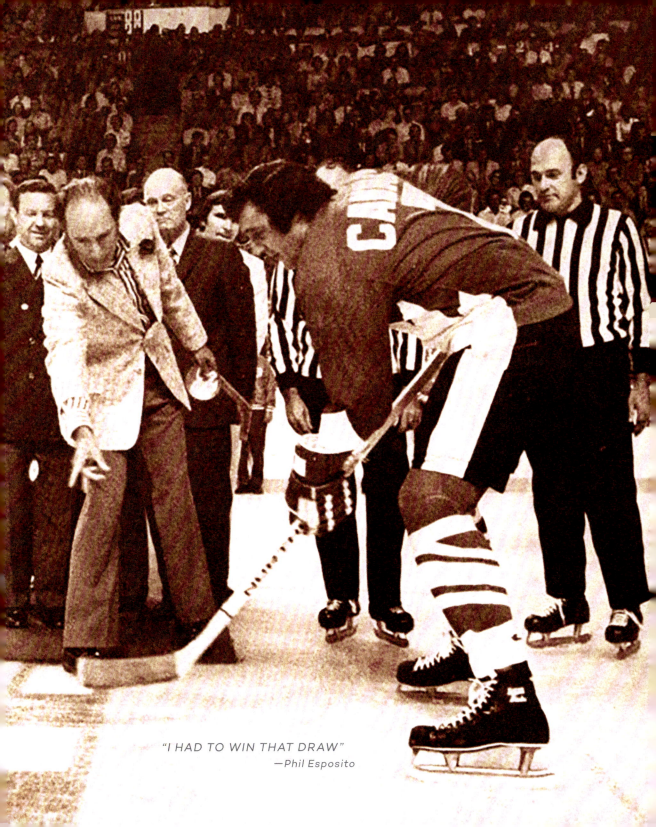

"I HAD TO WIN THAT DRAW"
—Phil Esposito

THREE

THE PUCK DROPPED. We tore after it. Five guys out of the starting blocks. There was nothing the Russians could do. Less than a minute into the game, we scored. The scream that couldn't get louder got louder. This was the way it was supposed to be. All those years of losing. Five minutes later, we scored again. Two goals in the first six minutes, six a period, eighteen a game—it's the way it was always going to be. But in the minutes between those two goals, and in the minutes after, when the game had to catch its breath, when the play had to be about more than just energy, when we were just us and they were just them, the game felt uncomfortably even. But it wasn't even—the scoreboard said so. But it *felt* even, disturbingly even. At some moment, their players and coaches would begin to feel that. We would feel it. The fans would feel it. It probably began to happen after they scored their first goal, or certainly after their second. This was now a game. This was now a series. The period ended 2–2.

d game an...
...ter and
...at
...rill
...ended.
...d. one of the
...ho won't be in
...night', said that
...atisfied if he got
... the games. "I
...ys who weren't
... beat Russia,
...laughing.
...res that if Ca-
...g a couple of
..."subs" will get
... or if the
... g ... but if
...d well, then it
...q"
... to Eagelson
... defeat to-
...parable to
...his week of
...'s Social
...h B.C.
...Eagleson
...ion that
...none

The l

Canada

GOALERS

29. Ken Dryden
35. Tony Esposito

DEFENCEMEN

2. Gary Bergman
5. Brad Park
16. Rod Seiling
25. Guy Lapointe
26. Don Awrey

FORWARDS

6. Ron Ellis
7. Phil Esposito
8. Rod Gilbert
11. Vic Hadfield
12. Yvan Cournoyer
15. Red Berenson
18. Jean Ratelle
19. Paul Henderson
20. Peter Mahovlich
24. Mickey Redmond
27. Frank Mahovlich
28. Bobby Clarke

neups

Russia

GOALERS

1. Viktor Zinger
20. Vladislav Tretiak

DEFENCEMEN

2. Alexander Gusev
3. Vladimir Lutchenko
4. Victor Kuzkin
5. Alexander Ragulin
6. Valery Vasiliev
7. Gannady Tsygankov
25. Yuri Liapkin

FORWARDS

8. Vyacheslav Starshinov
9. Yuri Blinov
10. Alexander Maltsev
11. Eugeny Zimin
13. Boris Mikhailov
15. Alexander Yakushev
16. Vladimir Petrov
17. Valary Kharlamov
18. Vladimir Vikulov
19. Vladimir Shadrin

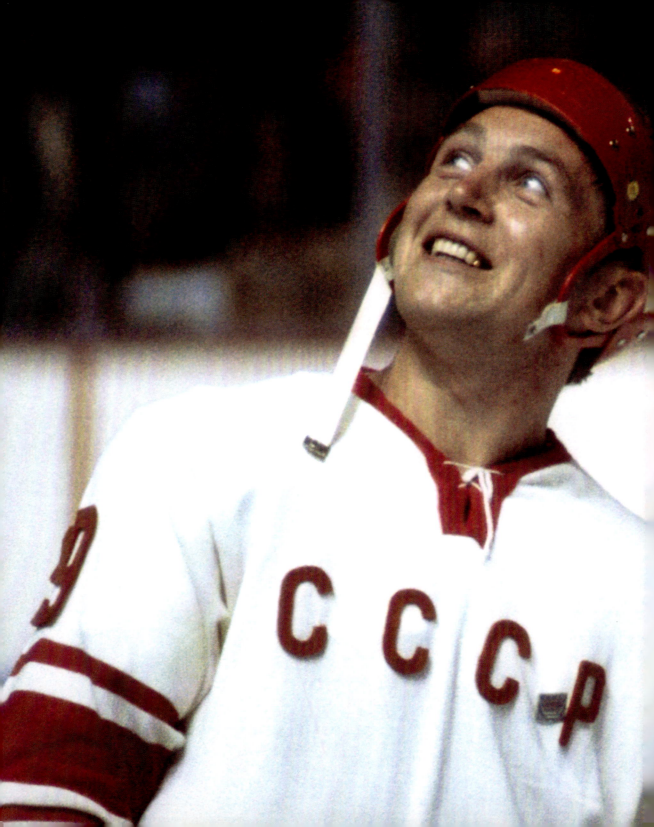

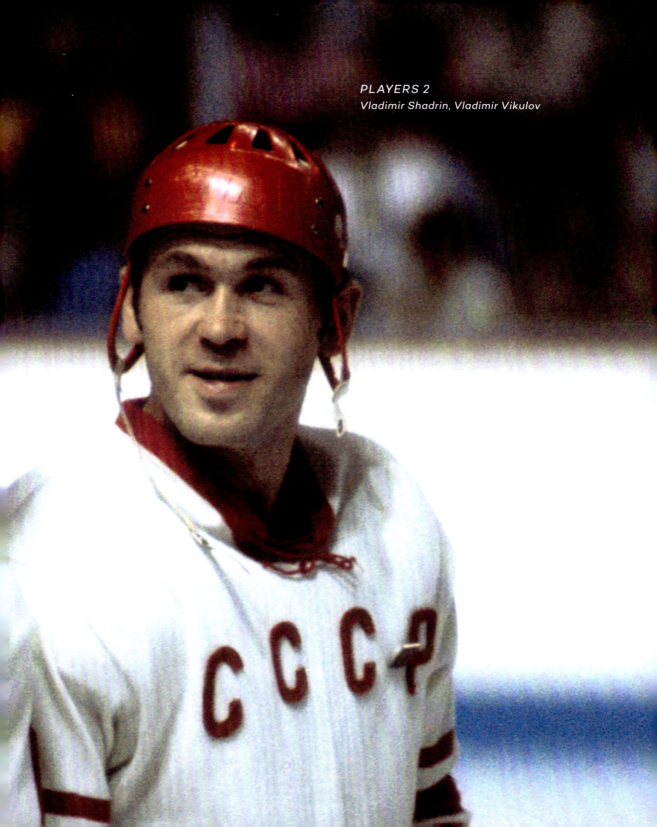

I remember Harry as he walked into the dressing room. "You didn't think it was going to be easy, did ya?" he said. And of course we didn't. And of course we did.

The game was tied. But now we were beginning to wonder, and now they were beginning to believe.

Almost buried in our confusion of feelings was one big feeling: if only we could have a redo. Start again. Train harder. Train for them, not only us. Have inside us the nagging fear of losing that you need if you want to win.

We had our moments in the last two periods. A big goal or a big save might have changed things enough to give us another chance, to adapt suddenly, to find a winning game to play in the non–big-energy moments. But we couldn't score the big goal, and I couldn't make the big save. The game began to slip away, and we could feel it, and we couldn't stop it. When that happens, there's anger and a fresh burst of energy at first—constructive energy—then frustration and more energy—destructive energy—but as the energy starts to die, disappointment sets in, then sadness. In the crowd, too. There is a photo I saw later. It was taken after one of their goals—I don't know which one—but it came later in the game. The photo is from behind the Russian net, looking up the length of the ice. In the building's heat, a slight fog has risen

from the ice. In the foreground, near centre ice, the Russian players are hugging each other. Behind them, our guys spread out, bent over, sucking for air. Behind all that, me, leaning on my stick. Behind me, the red light, still on, smudged by the haze, glowing bigger.

The final score: 7–3.

I didn't know what to think, what to feel, what to do. I didn't know what to say. Reporters always talk to goalies. In the dressing room after, I must have said something. I don't know what I said. I didn't want to look in any direction. I didn't want anyone to look at me. I don't remember feeling I had let everyone down—my teammates, my country. I was just embarrassed. I didn't want to hide. I wanted the world to go away.

After a loss, it's hard to see anything that isn't bad, that didn't go wrong. It's hard to see the things that were right, that worked, that might be right and work again. That is for another time, for tomorrow, when, a little less immersed in the disaster of today, you have no choice but to begin to focus on the next game.

TORONTO
Game Two

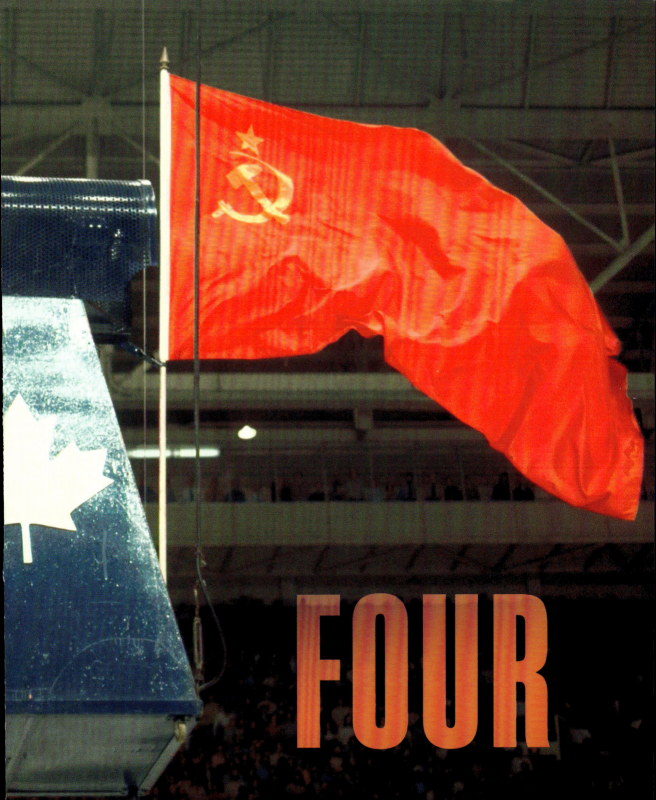

FOUR

I WOKE UP in a room I'd never been in before. We had flown to Toronto after the game and were staying at the Sutton Place Hotel. On the Montreal Canadiens, every player had a roommate on the road. On some other teams, goalies, often considered different and with odd habits, were given singles. In Toronto, I had a room on my own.

It was about nine o'clock. It was Sunday morning.

In Toronto in 1972, there were no Sunday newspapers. There were no all-sports radio or TV stations. In the room, there was no radio. On TV, there were no Sunday morning news shows. There was nothing around me, anywhere, that said that Saturday night had ever happened.

And until I left that room, it might not have. So, I stayed in the room. Practice was at noon. I had to be at Maple Leaf Gardens at 11:15. It was a fifteen-minute walk from the hotel. I didn't have to leave until eleven. I left at eleven. I didn't see

Sutton Place
Hotel

Sept 4, 1972.

There seems to be an air of not knowing what the problem is. On Thursday I was supposed to go to the CNE. They were int— before training started and — the line and

any of my teammates in the lobby, or anybody I knew or who knew me. The sun was shining. There was no evidence anywhere of anything. It was only when I walked into the dressing room that I knew for sure.

There was noise in the room. No laughter. More than twelve hours had passed. The energy was returning. Tomorrow, the puck would drop again.

There are few things less relevant than a goalie whose team knows he won't play the next game. I was out, Tony Esposito was in.

There were no videos to watch, to see what had gone wrong. No goalie coaches to tell me. Both such developments were years away. I had only my memory, and I wasn't ready for memory.

The next night, I would watch the game from the stands, as Tony had done in Montreal. When we weren't playing, Eddie Johnston would usually be the backup.

There is something different about a game that *has* to be won. You wouldn't think so. Each game, you try as hard as you can, or think you do. You give everything that's in you. But when

more has to be given, there *is* more somehow. It's always been there, you just didn't know it. The moment forces it out of you. It reveals it.

You would think that your opponent, knowing you had to win, would say, "We have to win, too," and play with the same desperation, knowing that if they do win, that final victory will be so much easier. But it almost never works this way. Willing your way to victory is one thing, the moment bringing you to it is another.

We had to win that game in Toronto. Phil Esposito had to be great. Others had to be their own kind of great. Tony Esposito had to be as good as the game pushed him to be, as good as his teammates needed, as good as a win required. There had to be some surprises. Harry Sinden and his assistant coach, John Ferguson, had gone with what they believed was their best lineup in Montreal. Now they needed a different best lineup. In Montreal, we looked too old and too slow. We had too many players who were great with the puck and not enough who pushed and grinded and got us the puck. We didn't play our game, our tough, hard-driving, sometimes un-pretty, do-what-it-takes Canadian game. In Toronto, we would. Seven players out, seven new ones in. Toronto hockey crowds, loud by Toronto standards, are quiet by everyone else's. Players called it "the Library." But that night, the fans were loud. They knew.

Phil was great. Others found their own kind of great. Tony, solid from the beginning, gave the team the message they needed—he would be as good as they needed him to be, as good as a win required. And there was one big surprise. Sometime in the third period, I think, when the game was exciting but grim, Pete Mahovlich, killing a penalty, took the puck from one end of the ice to the other and scored. Sitting in the crowd, I remember what I saw, but mostly I remember what I heard myself say: "Ooo . . . *ohh* . . . AHHH!!" as he went by one Russian player, then another, each with a move the moment demanded and that no one, including Pete, expected. He was making it up as he went along. For us, it was the first exciting *and* happy time of the series.

When you're behind in a game, you're looking for a "turning point." One instant that puts you over the peak of a tough, high mountain and onto the downslope of the other side. It's the same in a series. Pete Mahovlich's goal wasn't it, because as wonderful as it was, it didn't feel that way. The Russians were good, we knew that now, and they were going to keep being good. They were not going to allow this goal to drive them down. The series was not going to be won on turning-point moments. It wasn't going to be that easy. The score was 4–1.

There were six games to go.

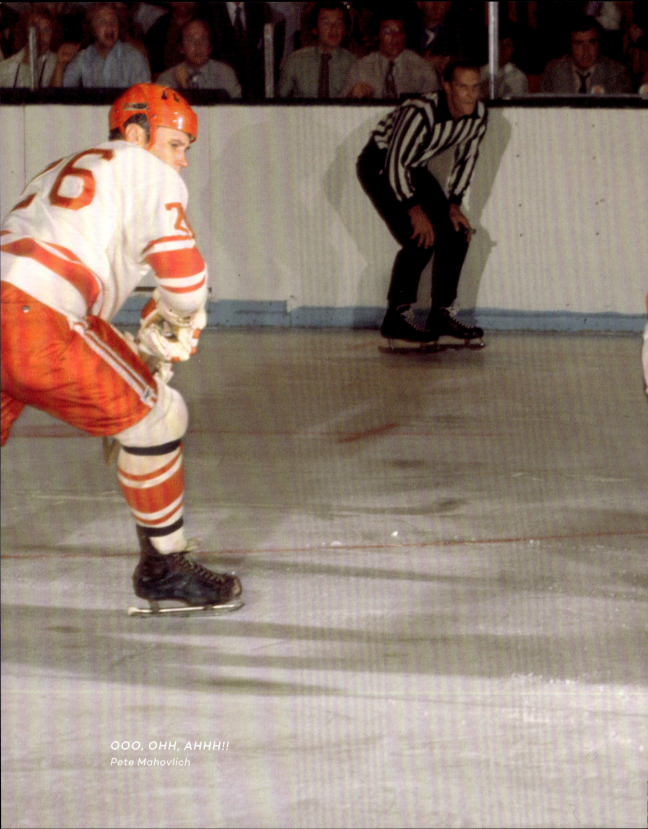

OOO, OHH, AHHH!!
Pete Mahovlich

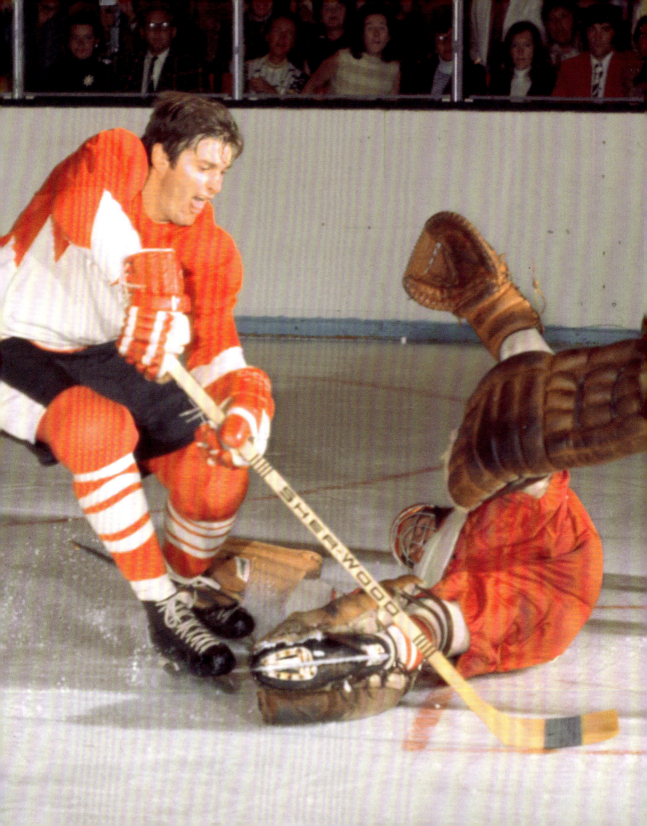

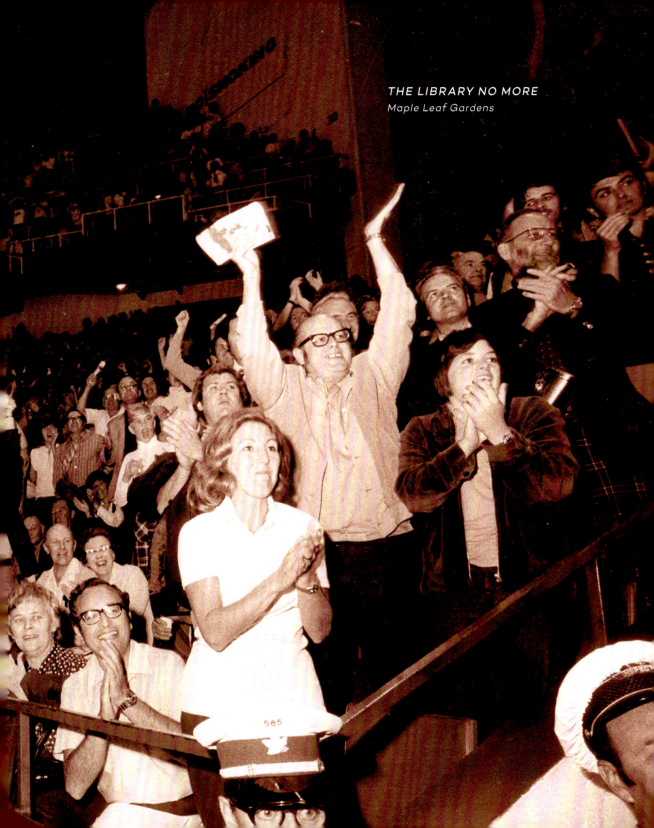

THE LIBRARY NO MORE
Maple Leaf Gardens

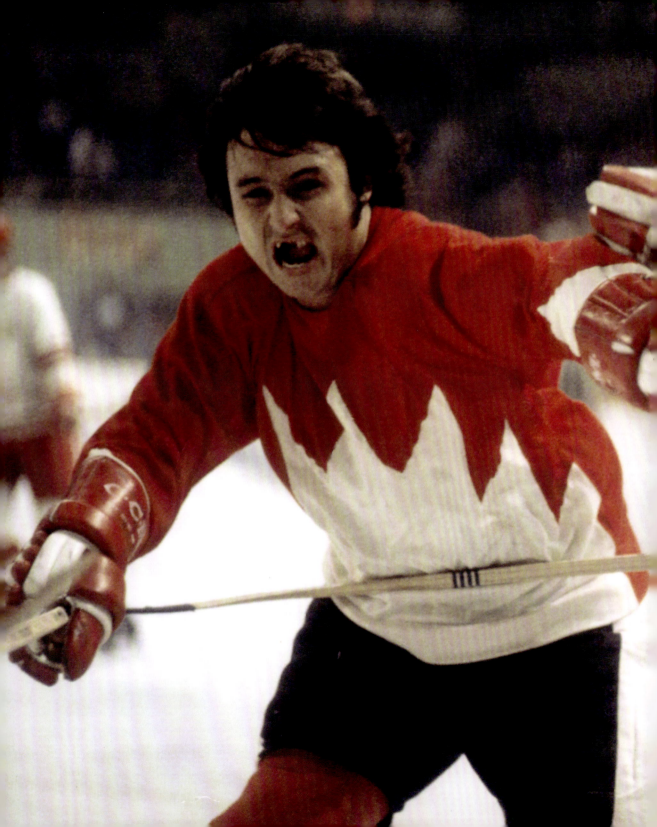

FIVE

IT HAPPENED JUST BEFORE PRACTICE.

We were in the dressing room in Winnipeg on the off-day between games. The mood wasn't the same as it had been four days earlier, before the game in Montreal, but it was better than it had been, and was almost fun. The dressing room was small, and with our equipment spilled out across the floor, it was hard to know whose was whose.

Now as a backup goalie, I needed to get out on the ice early to take shots from the players who wanted some extra work. I got dressed in the same order I always do, and my left skate was next, but I couldn't find it. I looked around in the equipment piles next to me, trying hard not to let anyone know what I was doing. It wasn't there. I looked under the benches. I sorted through the piles again. I didn't want help. Everyone has their own things to think about. But I was stuck. I couldn't put on my pads before I put on my skates. And the last thing a coach needs is for a goalie who isn't playing to be late for practice. Finally, I saw it. It was over by the door that led into the arena, its blade jammed under the door to hold it open. My skate was being used as a doorstop.

Red Berenson saw me walk over to get it, as nonchalantly as I could, and said in a voice more than loud enough for everyone to hear, "It's the only thing it's stopped all week."

I'm not sure when this happened, but in one newspaper column, NHL president Clarence Campbell was quoted as saying that I shouldn't have been the goalie in Game One, that I was too young and inexperienced. And I'm not certain when I knocked on Clarence Campbell's hotel room door. It wasn't in Toronto; it might have been in Winnipeg or Vancouver. He was courtly and respectful, as he always was. I left no less pissed off. He had been embarrassed by the Montreal game. The *players* had made bad plays, the *coaches* had made bad decisions. *We* lost. The NHL didn't lose. Campbell wanted everyone to know that.

In the Soviet net in the first two games, Vladislav Tretiak had been good. He was so unlike every other Russian goalie before him. The others—Viktor Konovalenko, Viktor Zinger—were small, hardworking, competent, no less but no more than what their dominant Russian teams needed. Tretiak was big, young, and athletic enough that he might be special. And because we expected him to be bad, and counted on him to be bad, he seemed even better.

The Winnipeg fans had mixed feelings about Team Canada, which they'd expressed openly and angrily since the series was first announced. Winnipeg had been the final home of the

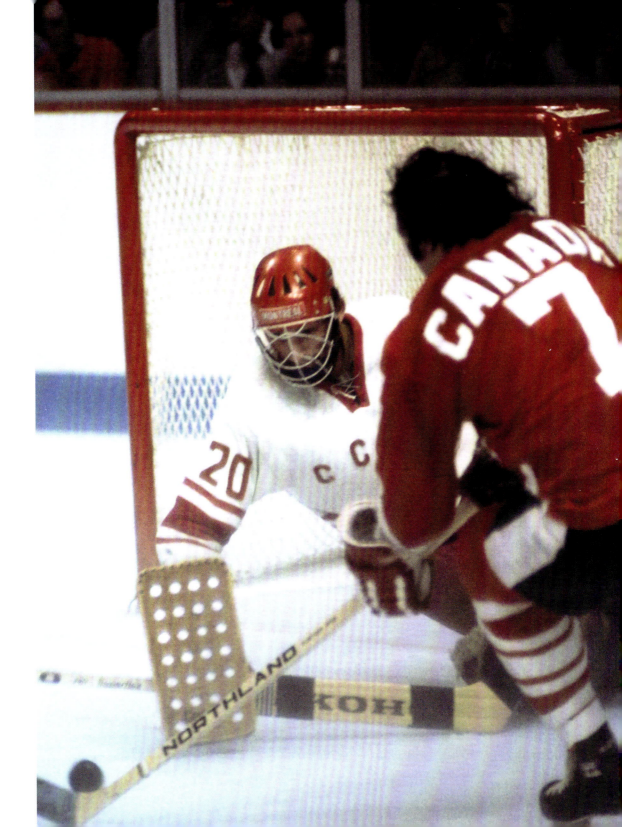

BREAKING THROUGH
Vladislav Tretiak

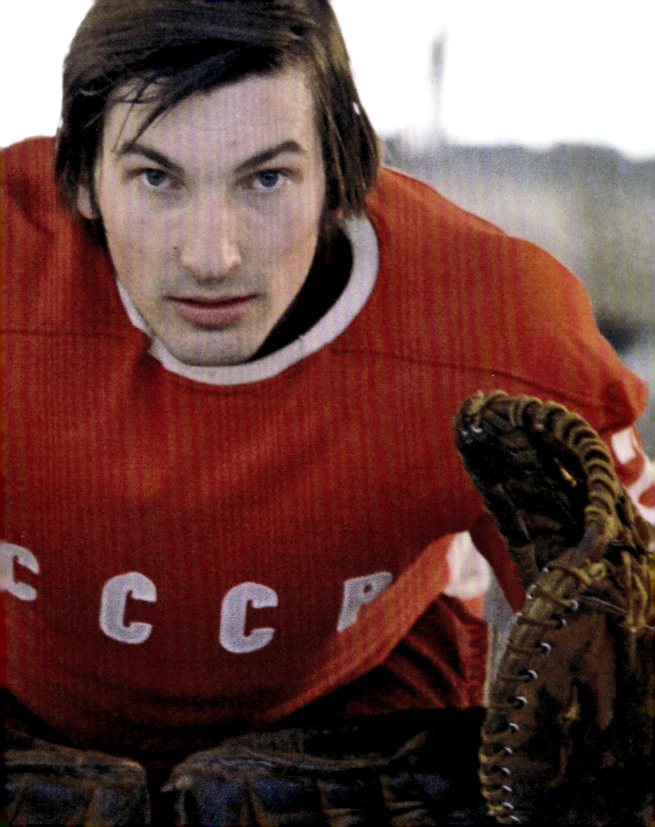

national team. Winnipeg saw it as *their* team. Winnipeg was to host the 1970 world championship. That the national team no longer existed, that the championship was moved to someplace else, that this series even had reason to be played, and, even more, that Bobby Hull was not on the team because he signed with *their* Winnipeg Jets of the WHA, was, to Winnipeggers, all about decisions made by easterners, by those in the political centre of Ottawa, in the economic centres of Toronto and Montreal, just as they had always been, forever and ever. One more example of the east *shafting* the west.

But when Game Three began the following day, all that was pushed to one side. This was their, *our,* Team Canada.

We picked up where we left off in Toronto. We didn't dominate, but we were better than they were. Better enough that we could feel ourselves getting into a comfortable flow, hitting our stride, becoming what we were. Even after giving up two short-handed goals, we were still ahead, 4–2, by the middle of the second period. But the Russians had their own surprise, their "Kid Line"—Vyacheslav Anisin, Alexander Bodunov, and Yuri Lebedev, whom none of us, even those who had played against the Russians before, had ever heard of—who brought them back into a tie, 4–4, where the game ended. For us, it was a tie that felt like a loss. For them, a tie that felt like a win.

They had arrived in Canada a team. We were still becoming one.

FOCUS ▶
Tony Esposito

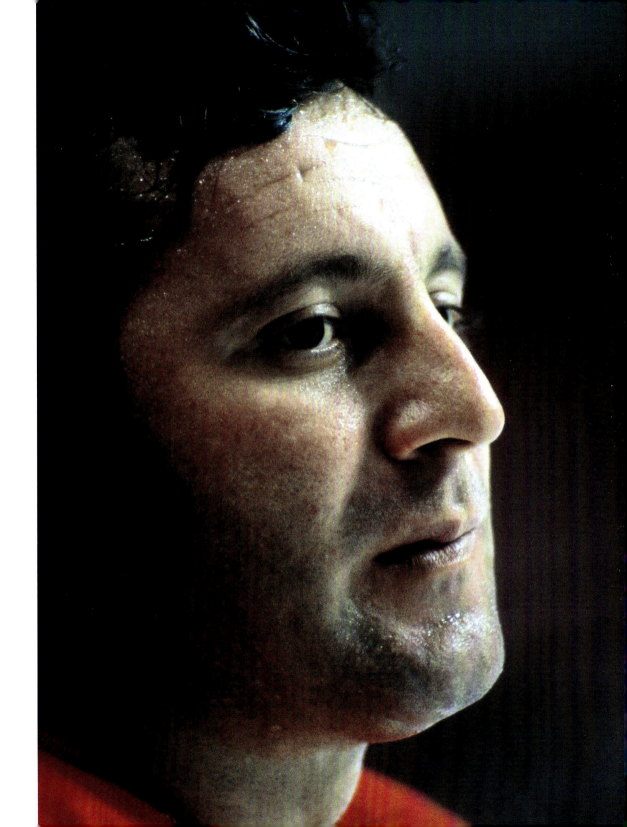

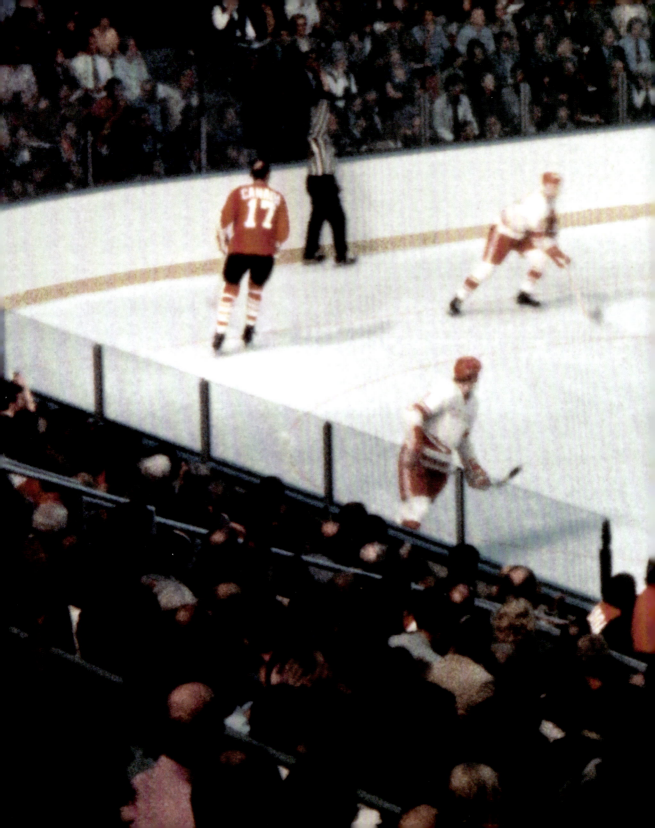

SIX

THE WHOLE NIGHT NEVER FELT RIGHT.

It was the last game in Canada, Game Four of the series. And however hard the first three had been, after it, the next four would be in Moscow. The shock of the loss in Montreal, the rebound in Toronto, the unsatisfying result in Winnipeg, all the games coming so fast, it had been easy to forget what this series was supposed to be: a celebration of Canadian hockey and Canadians, a demonstration of our brilliance, a coming-out party for all the world to see. And it had also been easy not to see that, after three games, the series was only even: one win, one loss, one tie. Whatever happened to eight straight? Whatever happened to smashing victories, to brilliance and dominance? Up close, in Montreal, Toronto, and Winnipeg, the games might have come to feel like a battle. Thousands of kilometres away, in Vancouver, on TV screens, they looked like a disaster.

Worse, the Russians seemed better at the fundamentals of *our* game—skating, passing, goaltending, team play. Sure, tough-ness and body contact are also what we are. Canadians are hard

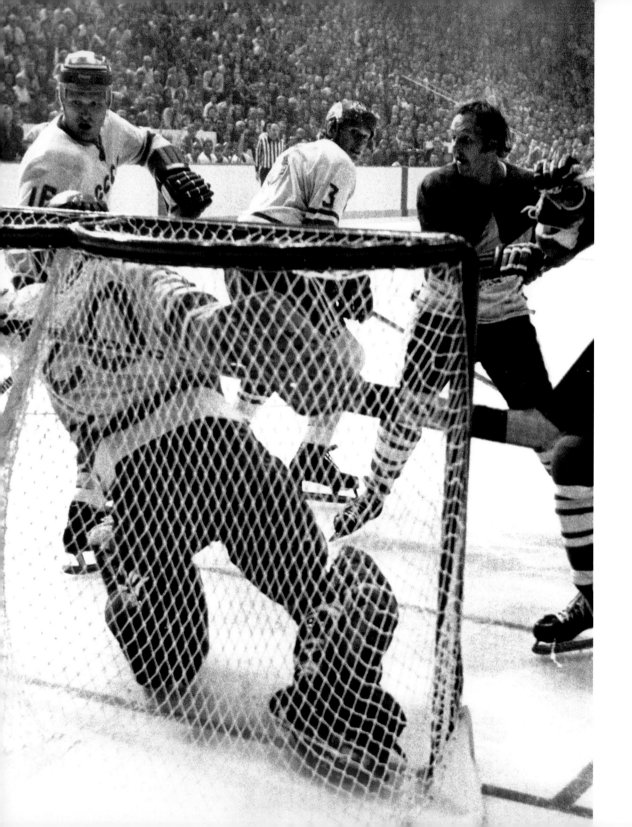

people. We've had to survive winter, harsh lands and times. We've had to meet these tests, and in hockey we demand that others do the same. Our opponents must show courage. They must never quit. And while these Russian players might not have been giving out punishment, they didn't back off, either. It takes courage to get hit and keep on going. By the time we reached Vancouver, Canadians were beginning to see this about them, too.

The Vancouver fans didn't begin the night surly. They booed us a little in the warmup, but they were ready to be anything. It depended on us.

We weren't good. We took two penalties early in the game, and they scored both times. It's the goalie's job to be good until the team finds its way, and I wasn't good. The game felt done and over before it ended. In Montreal, the long, slow losing had been numbed by the shock. This night, no numbing. Hope allows you to believe that if you do this, or try that, then something might happen, *could* happen. Hope is a great distraction. This night, no distraction. For more than two periods, I could feel my insides being sucked out.

The fans became angry—at us, at the way we played, at us being what they saw us to be: fat, out-of-shape guys who didn't care, who'd been paid the big bucks to play a little boy's game. Angry

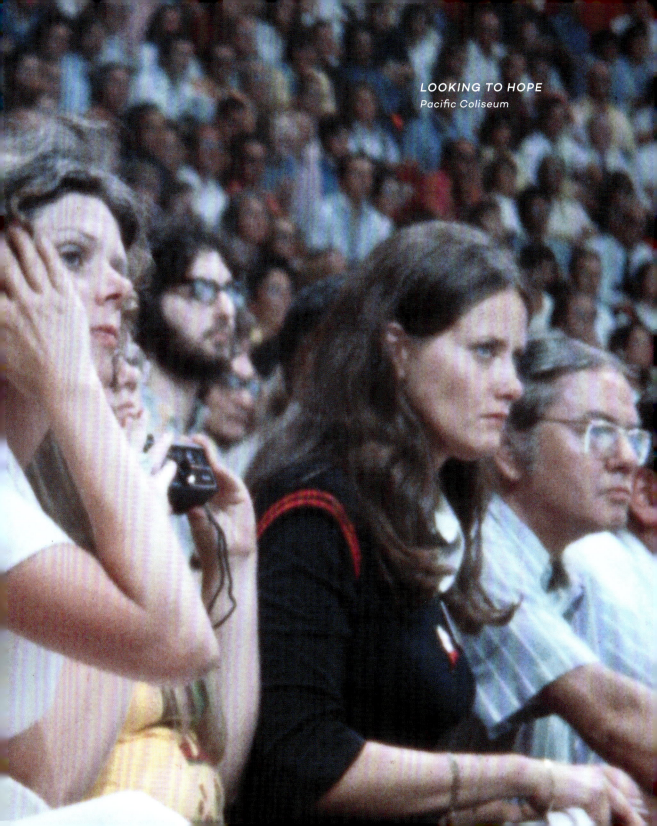

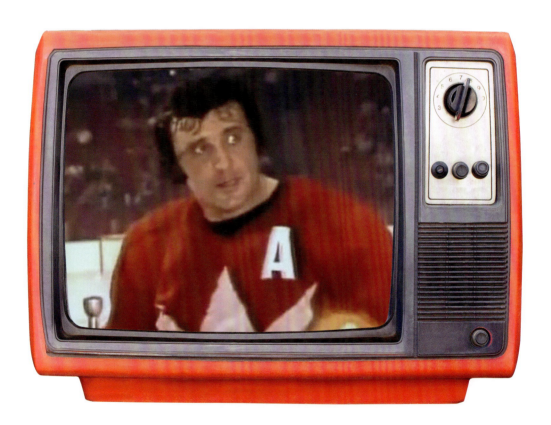

at us for ruining their party, the one they'd waited for for so long, angry at every resentment and grudge they'd ever had and held. Their anger never did turn to frustration, to disappointment, to sadness. They stayed angry. They wanted to punish us for punishing them. The final score was 5–3. And now we were down two games to one, one game tied. And now we were heading to Moscow, out onto a road we'd never been on before, to the Soviet Union, behind the Iron Curtain, to Russia.

Phil Esposito was interviewed after the game. We were in the dressing room; we didn't hear what he said. I never did see the interview until after the series was over. I think for most players, it was the same. He stood on the ice, his face drenched in sweat, his cheeks sagging from effort and exhaustion. He was angry, too, his voice rising, dropping, rising again. There was anger in his defiance:

> To the people across Canada: we tried, we gave it our best. And to the people that boo us . . . geez, I'm really . . . all of us guys are really disheartened and we're disillusioned, and we're disappointed at some of the people. We cannot believe the bad press we've got, the booing we've gotten in our own buildings. If the Russians boo their players . . . then I'll come back and I'll apologize to each one of the Canadians, but I don't think they will. I'm really, really . . . I'm really disappointed. I am completely disappointed. I cannot believe

it. Some of our guys are really, really down in the dumps. We know, we're trying like hell. I mean, we're doing the best we can, and they got a good team. Let's face facts. But it doesn't mean that we're not giving it our 150 per cent, because we certainly are. I mean, the more—every one of us guys, thirty-five guys that came out and played for Team Canada. We did it because we love our country, and not for any other reason. No other reason. . . . They can throw the money for the pension fund out the window. They can throw anything they want out the window. We came because we love Canada. And even though we play in the United States, and we earn money in the United States, Canada is still our home, and that's the only reason we come. And I don't think it's fair that we should be booed.

It didn't matter that we didn't hear his speech. Long before we'd ever been seen by the fans as fat, out-of-shape guys who didn't care, we were hockey fans ourselves. We were Canadians. The series mattered just as much to us as it did to Phil, to any Canadian. And seeing him now on their TV screens, the fans knew. He cared. *We* cared. Until the end of the series, it would be *us*—the team, the fans, the country—together.

Phil had set the NHL record with seventy-six goals in seventy-eight games two seasons earlier. He had won three scoring titles. He would lead both teams in the series in scoring, but

statistical achievements, carved in stone, get stuck in stone, and eventually get surpassed and forgotten. This speech created his legend, and legends grow.

The next thing I remember is flying back to Toronto. I was agitated. I couldn't sleep, then, suddenly, I was asleep when I didn't want to be. I hadn't taken out my contact lenses. This was a time before soft lenses, and hard ones needed to come out overnight; otherwise, under the eyelid, the lens shifts with each movement of the eye or lid and scratches the eyeball. When I awakened, it was as if my eyes had been scuffed with sandpaper. Even the slightest light was too much. I spent the next two days at home in bed in Montreal with patches over my eyes.

TIME OUT

3
PERIOD

CANADA
03
NO. PENALTY

USSR
05
NO. PENALTY

NOT HOW IT WAS SUPPOSED TO BE

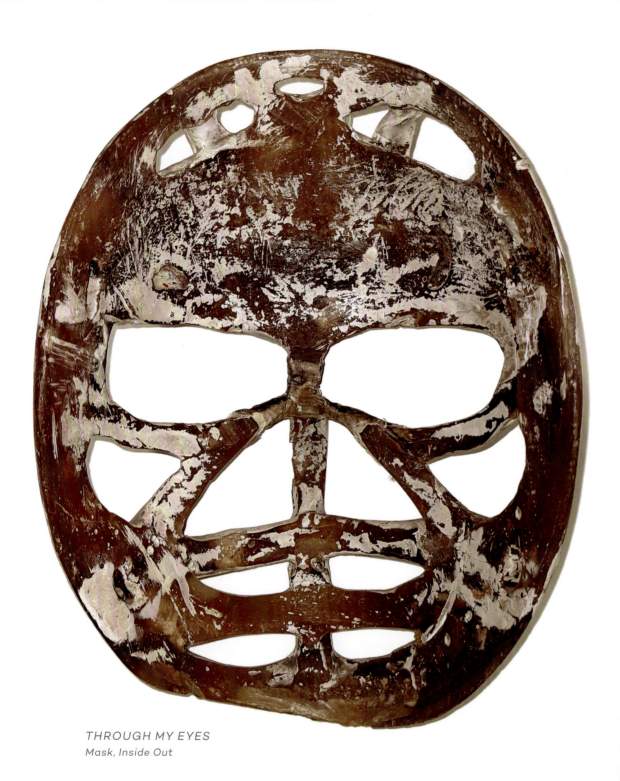

THROUGH MY EYES
Mask, Inside Out

SEVEN

WHAT'S GONE WRONG? What do I do now?

It was time to think. It wasn't time to feel. Feeling still hurt too much, feeling would make me re-see goals, re-hear boos, get mad and aggrieved, not mad and defiant. Feeling would make me sad. I had to get over sad.

I had to separate myself from myself. Distance myself. See myself as if I wasn't me, as if I was someone else. What I was doing wasn't working.

I had been too far out of my net, too often out of position, diving, sprawling, *anything*, to get to where I should've been. Playing desperately. My legs flying open, my arms flailing away from my body, open spaces everywhere—too much hope, too much confidence for the shooter. I had to get my game under control.

Our game, the Canadian game, the only one that mattered, had always been "headman hockey." You get the puck, your teammates break forward, you get them the puck. Most often, with passes to the wingers. Then, in the 1960s, ours became a power game, too, a slapshooter's game. Most often, the guy with the big shot was again a winger—Boom Boom Geoffrion, Frank Mahovlich, and, most of all, Bobby Hull. They shot so hard that if the puck was heading towards the corners of the net, no goalie could move far enough, fast enough to stop it. So, goalies learned to move out, to "cut the angle," so they didn't have to move so far. And they could, because they needed to focus only on the one big shooter.

Their game, the Russian game, was "possession hockey." You get the puck, your teammates break forward, sideways, backwards, wherever there's open ice, and you get them the puck. Opposing goalies, because the puck might come at them from any direction, learned to stay close to the net, to move not forward and back, but side to side. To focus not on the one big shooter, but to prepare themselves for a pass, and for a second and third shooter as well.

So long as we were playing our game in this series, the only game that mattered, I was fine. If they were good enough to play their game, too, I was not. In Montreal and Vancouver, I was playing a forward-and-back game against side-to-side shooters.

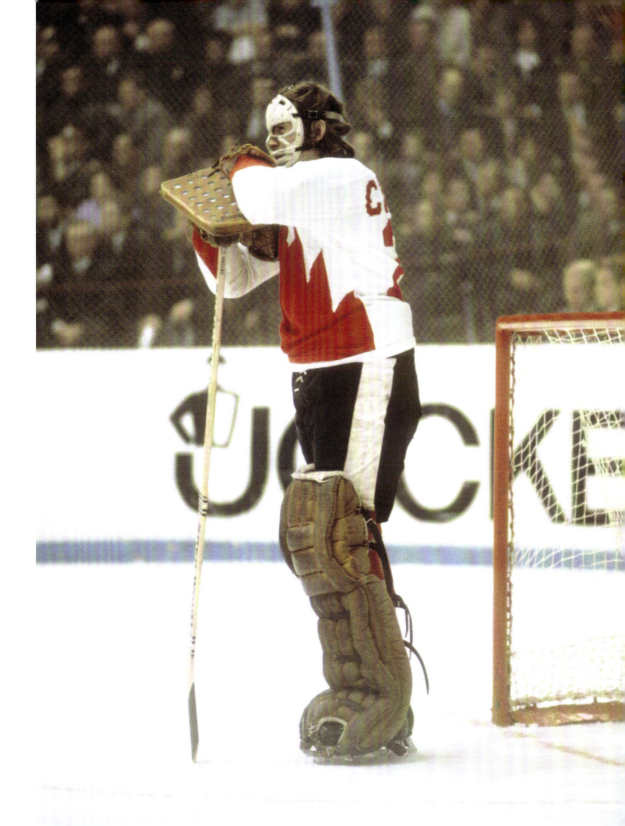

12 Winsdale Rd.,
Etobicoke, Ont.
Sept 9/72.

Dear Bill White,

Thank you very much
for the effort you gave &
will give to Team Canada on
our behalf.

All regular hockey fans
know they have been seeing
sensational hockey, & appreciate
your efforts.

Keep up the good work
in Russia.

all good wishes,

(Mrs.) Jean Wright.

I would have to unlearn in order to learn again, and it was not clear that I could, or could fast enough. Not clear to me, not clear to Harry Sinden, to John Ferguson, or to my teammates. But thinking about this at least gave me something to focus on that wasn't me. Thinking, at that moment, was a little bit about finding answers, and a lot about avoiding, escaping, running away. After Montreal and Vancouver, I was crushed. But crushed wasn't going to help. For me, now: think and do. Don't feel.

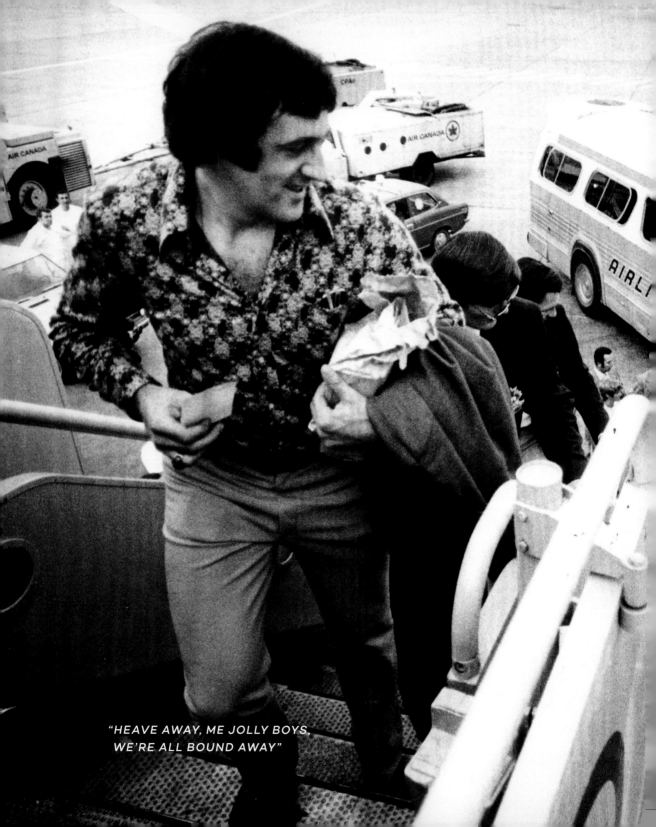

"HEAVE AWAY, ME JOLLY BOYS, WE'RE ALL BOUND AWAY"

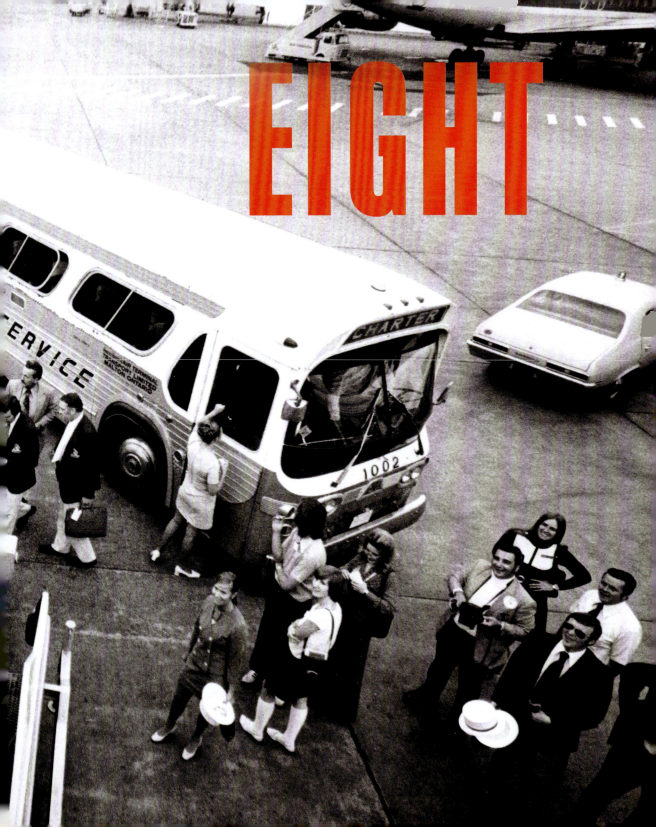

EIGHT

I DON'T REMEMBER much about Sweden, but what I do, I remember vividly.

This was to have been a nice time in a beautiful city. A well-earned break in the middle of the series as we basked in the glow of our four triumphant victories in Canada. Moscow, we knew, would be harder. A week or so in Stockholm, playing two games against the Swedish National Team, would get us used to a different time zone, to different hotels and different food, to the bigger European ice surface. In Stockholm, we would ease our way through our transition.

Sweden and Canada are a lot alike. We are northern countries, filled with wide-open spaces. If Toronto were moved north a hundred and fifty kilometres to the beginnings of the Canadian Shield, it would look like Stockholm—water never far from view, rocks, trees everywhere, both big, thrumming cities. And Canada and Sweden also love hockey. It's a game we're both good at, that seems natural to us.

But Swedish hockey players at the time set off Canadian hockey players much more than the Russians, Czechoslovaks, or even the Americans did. Swedish hockey players all looked perfect. They were all tall. They were all big and strong. They could all really skate. They looked like us, the way we wanted to look. They were every scout's dream. But when you hit them, they fell. When you hardly hit them, they took long, slow, theatrical dives. And when you hit them hard, they whined, they limped, they acted like they were half-dead. They were pretty, and we hated pretty.

The player who set us off most was Ulf Sterner, the prettiest and most talented among them. He was so perfect that, a few years earlier, he, a non-Canadian, a *European*, had been signed by the New York Rangers and had even played a few NHL games. But as a European player in the NHL, he was tested, and tested some more—slashes, high sticks, getting "run" again and again—by his skeptical, often resentful Canadian opponents, until he broke. And now, back in the safety of Sweden, he was swanning around the ice as if we didn't know better. Setting us off even more, he was their best player.

In the two games in Stockholm, winning the first and tying the second, we did what didn't seem like much to us in terms of hits, slashes, but seemed like a lot to them, even more to their fans, and even more to their media. Their tabloids shrieked out headlines, with stories that covered the pages of their

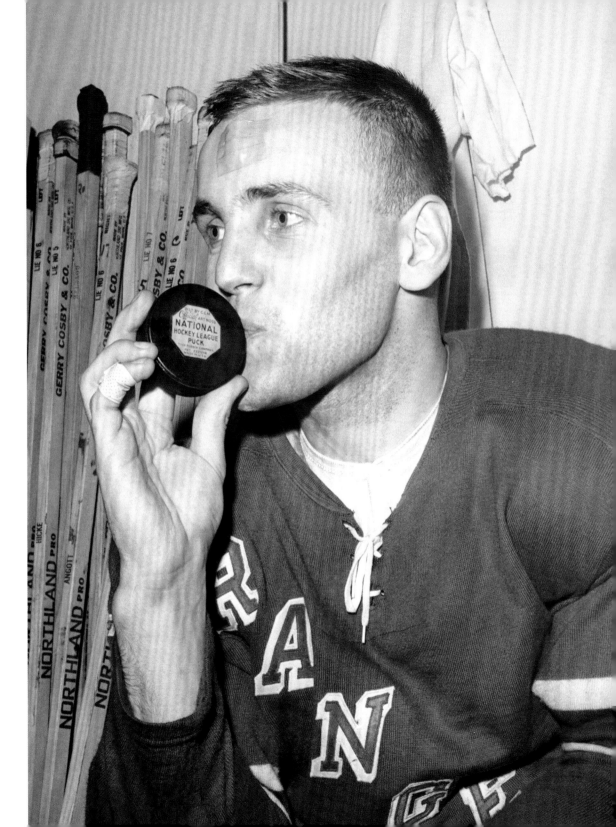

”Imponerad? Nej – det var ju en samling vedhuggare vi mötte”

TVÅ EXEMPEL PÅ DET RUFF som drog ner den sportsliga poängen i den annars dramatiska och intressanta 4–4-matchen mellan Tre Kronor och Team Canada. På övre bilden är Sterner illa ute mot uppretade Dale Tallon. Kanadensarens vilda swing med klubban missar dock. Båda åkte ut för slagsmål. Under: Lars-Erik Sjöberg, lagkapten och mycket skicklig, blöder illa från ansiktet. Han har fått näsbenet spräckt av Vic Hadfield.

FOTO: FOLKE HELLBERG

newspapers, casting us as criminals and thugs and them as our victims, blood streaming down their now-not-perfect faces. Tony Esposito played one game, Eddie Johnston the other. I didn't play at all. More telling, I was only a little surprised.

But if on-ice was a shambles, off-ice was not, at least to many of our players. For a team to become a team, its players have to know each other. What each is like, what they're good at and what they aren't, what they do in this situation and that. Do they panic? Do they get unnerved? Or do they turn clench-jawed and steely-eyed? You are in your teammates' hands and they are in yours. Can you count on them? Can they count on you, or not? You come to know in time, but we didn't have time. You come to know in big games. You come to know on the road. We were on the road at our training camp in Toronto, but there were thirty-five of us, the games hadn't yet begun, and, each of us knowing somebody in Toronto, there were other places to go and things to do. Nothing was urgent. In the series' first four games, we were going from bus to airport to hotel to rink, from city to city, hardly settling down anywhere. But in Stockholm, we had a week, we had nowhere else to go and no one else to do it with. It was only us, on the ice and off. It would only be us from now until the end. It was us, and us together, up against it.

In Stockholm, to many players, we began to become a team.

ARRIVING IN MOSCOW was not like arriving in Pittsburgh. We were now on the other side of the Iron Curtain. All of us had grown up in a Cold War world. In school, the big moments of the Second World War, we learned, had been fought on the western front. The war was about Churchill and Roosevelt, the Battle of Britain and D-Day. Maybe in a single day's class, we learned about the Germans invading the Soviet Union, the siege of Leningrad, the Russian winter that had slowed down Hitler when it seemed nothing else could, when we learned that the Russians were allies and that we'd fought Hitler together. But they never seemed to us like allies. Allies were friends. Britain, France, and the U.S. were allies. Maybe the enemy of my enemy is my friend, but the Soviet Union had never seemed like a friend.

Then, when the war was over, we were definitely not allies or friends. The bomb, the Berlin Airlift, the space race, the Hungarian and Czechoslovak invasions, Cuba—and, by 1972, to Canadians, not much felt different.

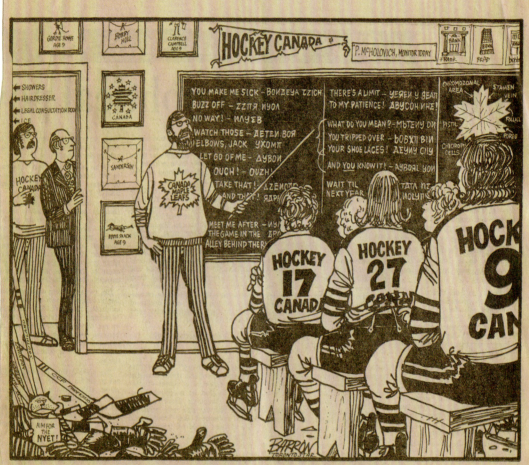

"... the players are getting a brief introduction to Russian vernacular
... we think it will help to avoid a lot of confusion on the ice ..."

North Americans were now travelling more, some even to Europe, but not many to Eastern Europe, and almost no one to Russia. Russia was *different*, in ways we knew, in ways we could imagine, and in ways we couldn't. It was dangerous. I had been there with the national team. I might have been the only player on Team Canada who had been in the Soviet Union before. Only a few of us had ever been outside North America or the Caribbean. With our own NHL teams, we were used to staying in Marriott hotels. Every bed was the same, every pillow, every phone, every shower and TV, every New York cut steak, can of Coke, and baked potato. In Moscow, we were at the Intourist Hotel, one of the newest and best in the city, just across a wide, multi-lane street from Red Square—the centre of the centre of the communist world.

Our beds were singles, not queens, our pillows were flat, our blankets were duvets, which we weren't used to, and which didn't tuck in. Our TVs were black and white, in a language we didn't understand, our shower heads slithered around at the end of bendy hoses, spewing water everywhere, in bath-tubs that didn't have curtains. Our breakfasts were buffets of cold cuts, smoked fish, white cheese, hard-boiled eggs, and chocolate-coloured bread that was hard and not chocolate. Our pre-game meals, our steaks that had been brought from home and had somehow "disappeared" into the Moscow air, steaks that had always made us feel strong and ready, instead were tough, random-sized, random-shaped hunks of meat.

Our phones rang in the night. Our elevators bumped, paused, and came to a halt a few inches above or below our floors. And before we could get our room keys, we had to get past a grim, implacable, unimpressible floor lady who was the real reason Hitler never made it to Moscow.

All this might have been funny if we weren't behind in a series we had to win.

Then there was the arena. We were used to rinks two hundred feet long by eighty-five feet wide—except the Boston Garden, Detroit Olympia, Chicago Stadium, and the Aud in Buffalo, which were smaller. Luzhniki Arena in Moscow was bigger, international-sized, two hundred feet by one hundred. Fifteen feet may not seem like much, but it means an ice surface more than one-sixth larger, with more open spaces to roam if you're a forward, to cover if you're a defenceman, to escape to if you're being hunted down. Both forwards and defence use the boards as a reference point. A pair of defencemen know to position themselves far enough from the boards that they are close enough to each other to prevent a shooter from going between them. A forward knows he can go wide near the boards, for a while, then needs to give himself time to cut in and get to the net. But defencemen oriented by boards fifteen feet farther apart leave too wide a space between them, and forwards, too far from the net, run out of time to get there.

CHAMPIONSHIP FIGHT ▶
Poster

22, 24, 26, 28
СЕНТЯБРЯ

ХОККЕЙ

СССР·КАНАДА

(СБОРНАЯ) (СБОРНАЯ ПРОФЕССИОНАЛЬНЫХ КЛУБОВ)

НАЧАЛО **22** СЕНТЯБРЯ в 19³⁰

24 в 20ч

26 в 19³⁰

28 в 19³⁰

For the Russians, more space meant more open ice to play a possession game. It made them harder to hit. But if we were dominant enough to play our game, what did it matter?

One more thing almost no one expected—Vic Hadfield, Rick Martin, Gilbert Perreault, and Jocelyn Guevremont decided to go home. Hadfield, Martin, and Perreault had played a little—of the four, only Perreault might have played again in the rest of the series. As players, all of us had been in big games before, but none of us had been in games like this. All of us had lost when we should've won. All of us had been embarrassed and humiliated, but not like this. We thought we knew ourselves, we thought we knew others. We didn't. We couldn't. Some rise to an occasion, some don't. Some grow, some lose it. Some do dumb things. Things they would never do, and never do again, that made sense to them then, at that moment, and wouldn't make sense again. After Montreal and Vancouver, after Stockholm, this was one more distraction. At home, the players' departure would've played out for days. But here, now, for us, only minutes. We had a series to play.

Me, I was just focusing on practice. I would work on my game, learn, adapt, go out early and stay late to take shots for those who were looking for a little bit extra, and in the back of my mind, make myself as ready as I could to play in case I was

asked. Thinking *and* doing. And if I wasn't asked, with NHL training camps now going on at home, I'd get myself ready for the NHL season that would begin soon enough.

Harry Sinden and John Ferguson now knew the team they wanted. They had seen what did and didn't work, and they had adapted from game to game. They saw how the Russians played. Harry and John were the first coaches ever to put together the best thirty-five hockey players that Canada had. It was a team, *truly*, of all-stars. But they learned, and we learned, that a game against a great opponent requires not just all-star scorers, but all-star checkers, all-star penalty killers, all-star grinders, all-star competitors. It requires an all-star *team*. Because a game or series against an opponent like this has ups *and* downs, moments to score *and* moments to survive, and to win, you have to be able to handle them all. So, Bobby Clarke, Paul Henderson, and Ron Ellis went from afterthoughts to core players, and Pat Stapleton and Bill White, Serge Savard and Guy Lapointe came to play more and more minutes. Also by now, the promise Harry made to the players when he first chose them—that we'd each play at least one game, a promise he felt he had to make to stars in a series we knew we'd win—was now gone, past. The only promise that remained was the only one that mattered. A coach's promise to a team: the players who should play, will play.

Tony Esposito played Game Five. I watched from the stands. Sitting above us in a special box, Soviet premier Leonid Brezhnev and president Nikolai Podgorny. The night didn't begin well.

International games have ceremonies and rituals. Before Game Five, there was an exchange of team banners between players, and being the opening game in Moscow, a presentation of flowers from two young girl skaters to the two team captains. Phil accepted his roses, then slipped, struggled to find his balance, and landed on his butt. He had stepped on the stem of a rose that had fallen to the ice. The Canadian players and Canadian fans gasped. The Russian players and Russian fans gasped, too. It was a dig-yourself-a-hole-and-jump-in-it moment of the worst kind. Phil slowly got up to one knee, and, with his other leg extended, bent at the waist, sweeping his right arm forward across his body in a knightly gesture. The players, the fans, Russian and Canadian, couldn't believe it. If you've got beets, make borscht.

We played exactly the way we didn't play in Stockholm. Exactly the way we wanted to play. We were quick, sharp, and smart. We led, 1–0, at the end of the first period, 3–0 at the end of the second. Then they scored, we scored, and then, in a stretch of less than six minutes, they scored four times and won, 5–4. We played even better than we had in Toronto, and we lost. It was encouraging, and awful.

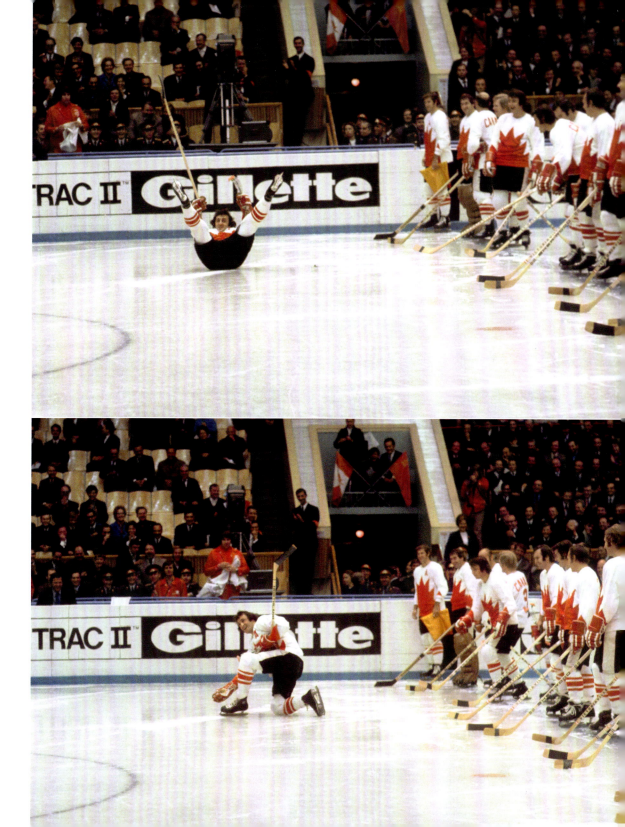

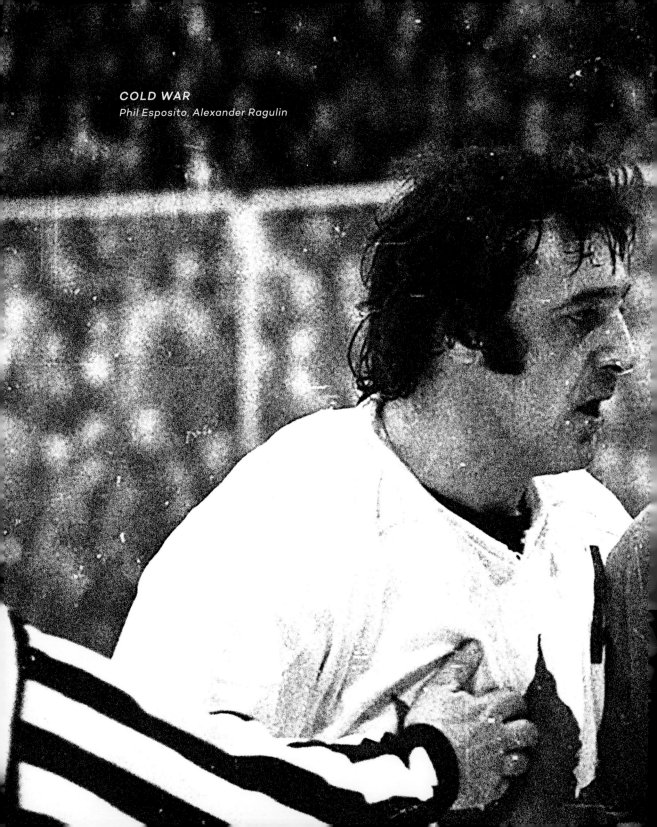

COLD WAR
Phil Esposito, Alexander Ragulin

TEN

AT PRACTICE THE NEXT DAY, Harry called

Tony and me over. I would play Game Six, he told us. Tony, Game Seven. I would play Game Eight.

I don't remember much about the next two days. I remember on my earlier off-days in Moscow, filling my non-practice time just doing things—going on tours that we all went on. Wandering around Red Square by myself, taking in its incredible size, its cobblestones that echoed even under the shoes I wore, remembering TV news clips I'd seen of May Day parades there, the soldiers, thousands of them, marching perfectly, ominously. Imagining the sounds their boots made. The tanks, the missiles and missile carriers, Brezhnev, Kosygin, Podgorny looking on from the top of the Kremlin walls. It was a place that oozed power. Stifling, exciting power. Lenin's Tomb, and outside it, day or night, the lineup that never ended. And St. Basil's Cathedral, like no church I'd ever seen or could ever imagine, its onion domes, its fantastical colours, in such a dark, drab place. I also went to sports institutes and sports

clubs to talk to them about what they knew, about sports, about hockey, about how they thought. I asked questions. I found everything *interesting*. Going deep, but not too deep, hoping, pretending I might learn something that would be a clue to that answer I hadn't found. To see what was there to see, and not to feel what I felt.

Now I'd be back in goal.

I don't remember much of Game Six. It was a game that should have been played with the frenzy of Game One, or the growing confidence of Game Five. But it wasn't. We knew the series wasn't over, but we played as if we didn't quite believe it. The Russians played the same way. We didn't quite feel hope. They didn't quite feel fear. Yet, the series surely *was* over— the Russians were ahead, three games to one, and the last three games were in Moscow. All they had to do was win one. At home. Even a tie would probably be enough, their goal differential being much better than ours. Instead, the game seemed to drift. The teams, both of us, like cyclists in a velodrome, each eyeing the other, waiting for the other to make their break, to begin their sprint, then sprinting after them in a mad race to the end. We took lots of penalties in the second period—thirteen minutes, plus a ten-minute misconduct, to their four. There was a spasm of goals, but none were scored in the first period or the third. We won, 3–2.

Even little things seemed to matter. Every bump of the elevator was more jarring. Every call in the night more aggravating. Every ride to the rink, rush-hour traffic or not, seemed worse. The Cokes that had been promised every day, and every day didn't arrive—that biting, crave-generating taste from home. Finally, today, for sure, they'd be coming. Instead, Jolly Cola from Denmark! And the referees, a not-so-little thing. In international hockey then, there were two of them—no linesmen—and both referees were in equal control. To prevent possible bias, no referee in the series was Canadian or Russian. But what about the Americans? What about the West Germans or Czechoslovaks? Were they inclined or beholden? Did they want *them* to win, or us? All the penalties we were getting, we deserved more than they did, but *that many* more? As the off-ice disputes got bigger and greater, Eagleson was more and more everywhere.

ON OUR WAY ▶
Pete Mahovlich, Dennis Hull, Rod Gilbert, Phil Esposito

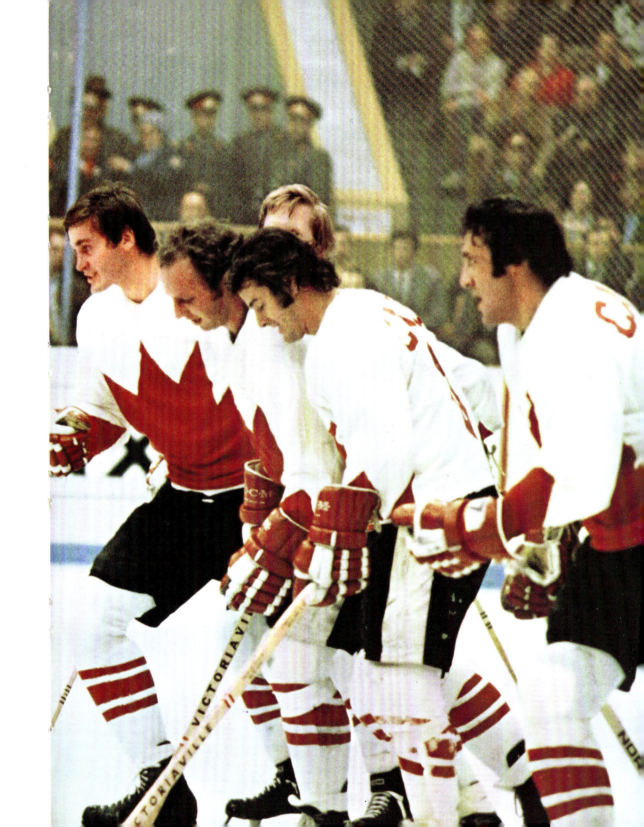

BRAIN TRUST
(L to R, top): Unknown, Dick Beddoes (Globe and Mail), Gilles Terroux
(La Presse); (L to R, middle): Ted Blackman (Montreal Gazette), Alan
Eagleson, Jean Béliveau, Red Fisher (Montreal Star); (L to R, bottom):
Mark Mulvoy (Sports Illustrated), Pierre Gobeil (Montréal-Matin)

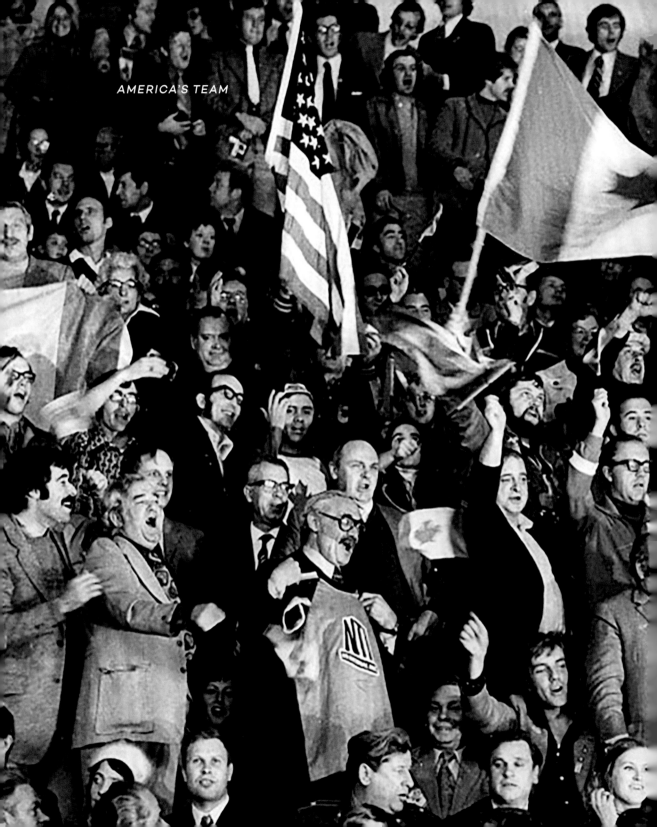

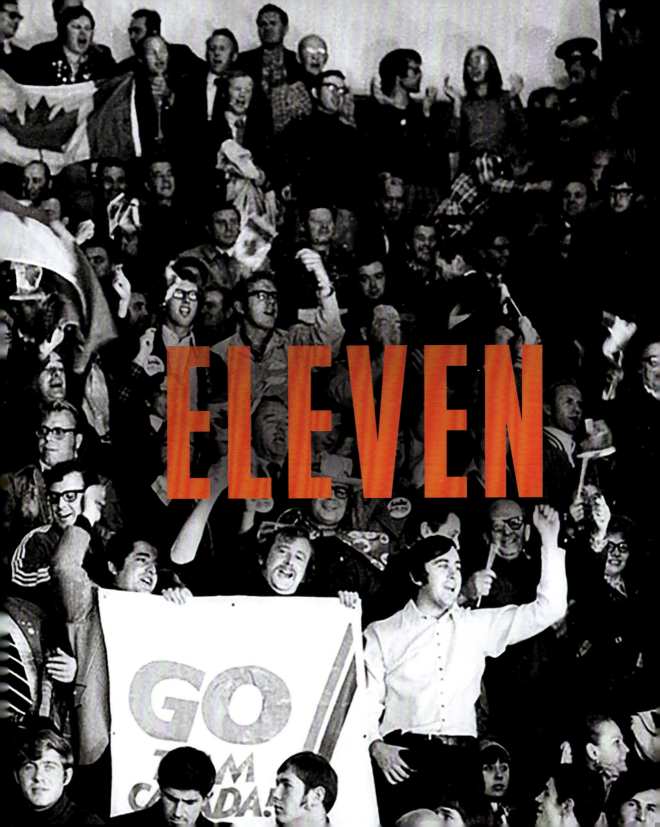

ELEVEN

TONY WAS BACK IN FOR GAME SEVEN.

I was in the crowd. What I enjoyed most about these games in Moscow was the Canadian fans. Three thousand of them! Most of these fans didn't have a lot of money. Many of them were from small towns. And these fans weren't there to check off one more item from their bucket lists, to be able to tell everyone they would ever meet in their lives that they had been there. They didn't make this moment about them. Instead, it had something to do with a feeling they had for their country and a feeling they had for hockey, and some mix of the two that they didn't quite understand. They just knew they needed to be there.

The signs they made: SARNIA'S HERE, WHITEY! And Pat Stapleton, who was born and raised in Sarnia, knew again what he already knew: that he mattered, and we mattered, and Sarnia mattered. And the chant the fans came up with. In international games before, Canadian fans had sung out

FROM EVERYWHERE

MINS, ONTARIO
TO
MOSCOW
ANK & PETE

"Go, Canada, Go!" But this was Russia. It must have begun with one fan, maybe in a bar, maybe in the stands, and then a few more picked it up, then many more, then all three thousand, belting it out, sounding like twenty thousand:

DA, DA, KA-NA-DA
NYET, NYET, SO-VI-YET

When Russian fans cheered, they yelled, *"Shaibu!"*—"Score!" When they got angry, they didn't boo, they whistled. In a jammed Luzhniki Arena, it was a head-exploding sound. But when the Canadians sang their song, and Russian fans, not used to non-Russian fans in their midst, certainly not three thousand of them, whistled in disapproval, they couldn't drown them out. They couldn't discourage them. For Canadian fans, this was *their* fight to win.

Then there were the telegrams. Before email and Twitter, they were a way to say, in just a few words, what a letter or phone call couldn't. These telegrams came from thousands of kilometres away, from people we didn't know. We read them, then more arrived, then many more, and we read them, too. Our

trainers taped them on a wall near our dressing room, then ran out of space and taped them down one side of a corridor, then across on the other side. There had to be thousands. Just someone's name, their hometown, and a little message that made us know that what we were doing meant something.

I remember nothing about Game Seven except the fans singing and chanting. Henderson scored with only two minutes to go, and we won, 4–3.

It wasn't until his goal that I began thinking about Game Eight. Game Eight didn't matter if we didn't win Game Seven. Now Game Eight was all that mattered. And I would be playing.

I left my seat in the stands as the game ended, to go down to the dressing room. The Canadian fans were celebrating. I was trying to celebrate with them. We walked through the mezzanine under the seats; the ushers had opened the outside doors for the fans to leave the building. Snow was falling, the first snow of the Moscow winter. When the Canadian fans saw it, a few of them, then a few more, then all three thousand, began singing "White Christmas." It would have been fantastic, I would have loved it, except I could only think about Game Eight.

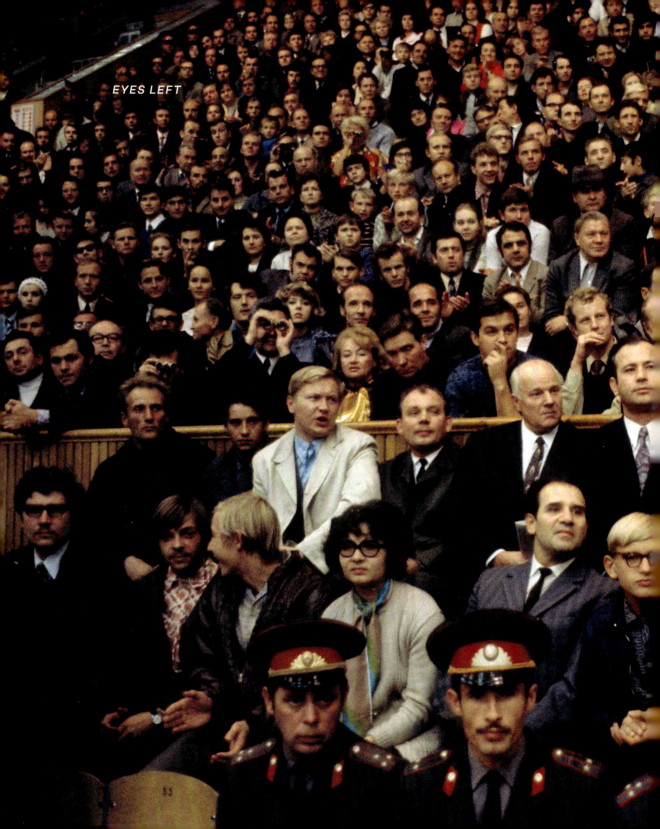

EYES LEFT

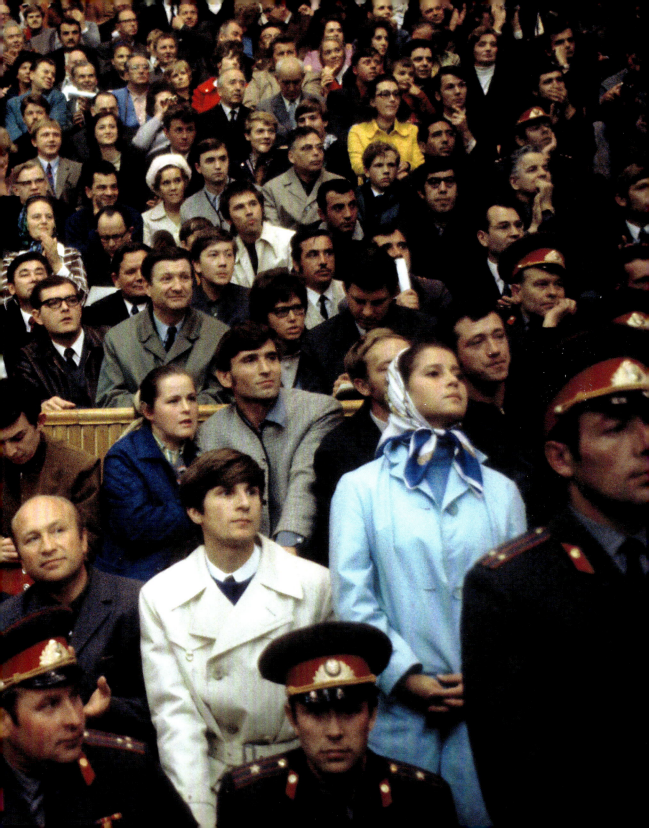

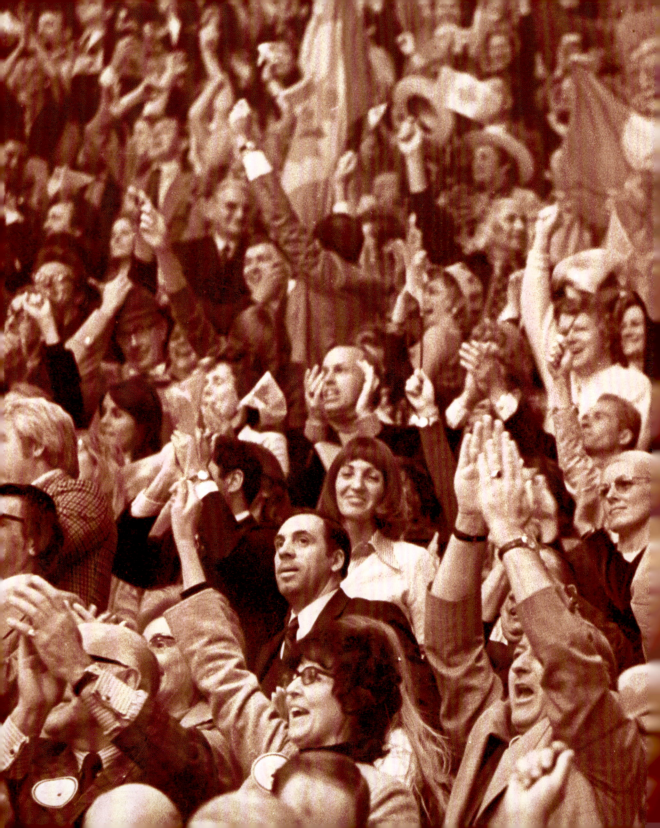

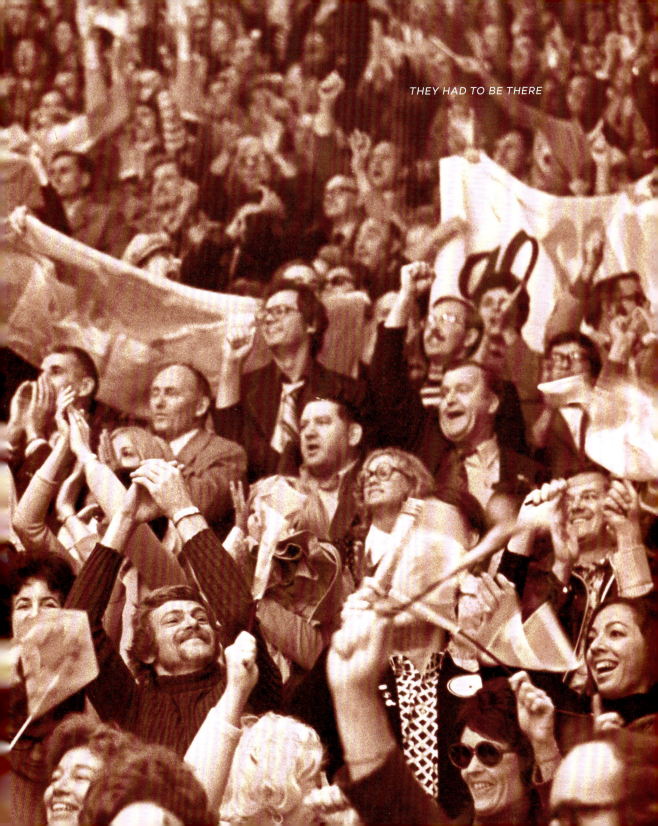

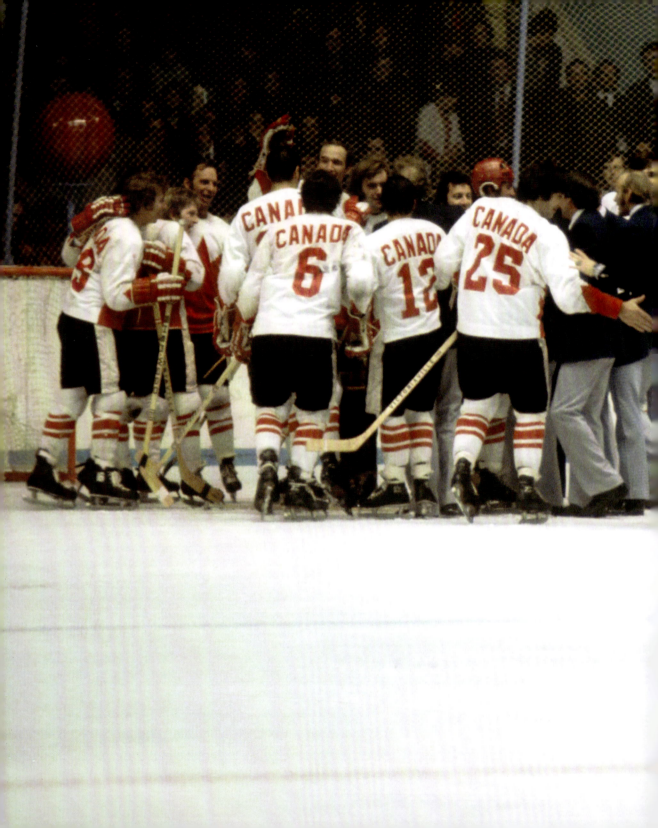

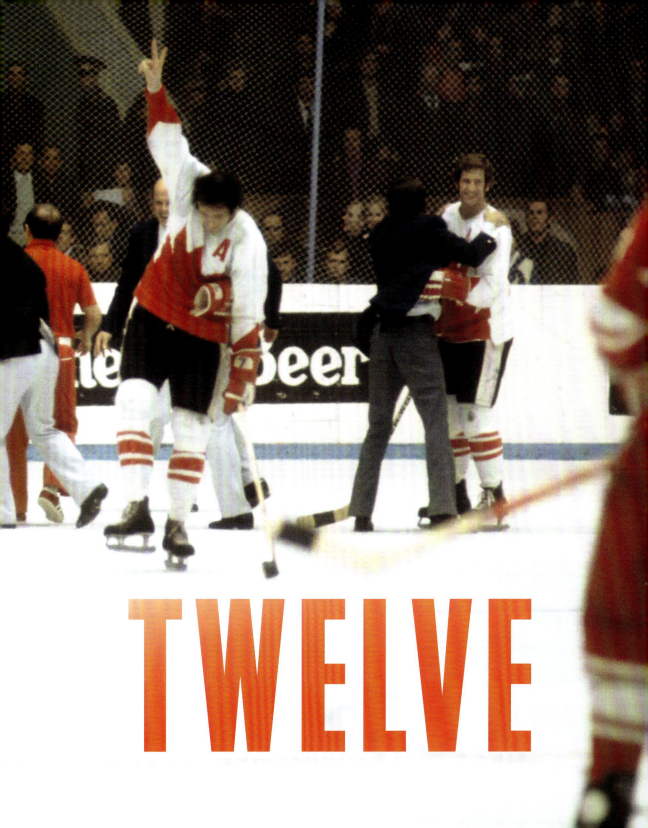

TWELVE

WHEN I WOKE UP THE NEXT MORNING,

my legs felt like jelly.

Thirty-six hours to game time.

I would get nervous before games. Every game is an unknown. You know your team, you know yourself, you know your opponent, you've gone through this thousands of times before, but not exactly. Not for sure. Something different might be awaiting. What, or when, you don't know, and can't know. Can you handle it? Are you up to it? Only when you face it do you know.

And you know about all this even when you don't think about it. Think and do, don't feel? Not this time. Not now. My body knew, my mind knew, *something* knew, and I couldn't stop it.

I got nervous in my stomach. I never got nervous in my legs. I never got nervous two days before a game.

I tried to keep busy. I tried to focus on every little thing— *I think I'll wear this shirt today. No, maybe that one. Yes, that one. And why not the hard-boiled eggs this morning, and that cheese looks good. I wonder what Red Square is like today.* I didn't need to think about tomorrow. It wouldn't help me if I did. *Maybe I'll walk over to the Metropol Hotel.* Then, out of nowhere, my legs wobbled again.

That's what it was like for almost two days—doing something, doing anything. I don't remember what I did, it doesn't matter what I did. I was only doing it to avoid doing something else. But this time, I could never do enough, stay busy enough.

The hours passed. Bus, arena, practice, bus, hotel. Word spread through the team—Harry, John, and Al were meeting with the Russians, there was a big fight over the referees. We had a deal: one of the refs was to be the Swede, and now they wanted the two West Germans—Franz Baader and Josef Kompalla, or "Baader and Wurst," as we came to call them—for the final game. They'd given us all those penalties in Game Six. They could hardly skate. We were threatening to pull out. I remember thinking, "Stick to your guns, Al." If we pulled out, there'd be no Game Eight. No Game Eight for me to play. A way out when there was no way out. Something else to focus on, pass time, to not focus on something else.

We avoided "Wurst"—Kompalla—but we got Baader.

I knew what was at stake in that game. I knew without thinking about it. That's why my legs wobbled. I knew about hockey and why it matters to Canadians. I knew what losing all those years had done to us. I knew this would be a historic series even before it began, not just because it was the first time the pros had played the amateurs, that the best had played the best, but because every Canadian, fan and non-fan, would be riveted by it. And then it had become even more historic, even more riveting, when the Russians won and made it a real series.

I knew the stakes in that final game, too, because I knew sports. I'd followed sports all my life. I love sports. I remember Roger Bannister beating John Landy in the British Empire and Commonwealth Games in Vancouver after breaking the four-minute mile. I was six. I watched Tracy Stallard give up Roger Maris's record-breaking sixty-first home run, American John Thomas losing the high jump in the Rome Olympics to Robert Shavlakadze, to the Russians, and Canadian Harry Jerome lose the hundred-metre dash to Bob Hayes. I knew the legacy of Bannister, the winner, and the rest. I knew the legacy of Landy, the loser, and the rest. I knew that historic moments create historic heroes and also historic goats. Heroes and goats, that no matter what else these athletes did in their lives, would never stop being heroes and goats. In more recent

times, the Boston Red Sox' Bill Buckner, a good player who'd had a good career, until one ground ball trickled between his legs and nothing else mattered. For me, the lesson had come from a story I'd heard when I had been too young to watch. It was 1951, the Brooklyn Dodgers were way ahead in the standings, and then started losing. The New York Giants started winning, and the regular season ended in a tie. There was a one-game playoff. The Dodgers were ahead. It was the ninth inning. The Dodgers brought in Ralph Branca to pitch. The batter was Bobby Thomson. It would come to be called "The Shot Heard 'Round the World." Thomson hit a home run, the Giants won the pennant. Thomson became a forever hero, Branca a forever goat.

This series would produce a historic hero. It might produce a historic goat. No one had known it would be Bobby Thomson or Ralph Branca. No one knew who it would be now.

At some moment that day, September 27, 1972, the day before Game Eight, when I couldn't stay busy enough and couldn't race my mind fast enough, I knew I could wake up on September 29, 1972, the most hated person in Canada.

The next day, by the time I got to the rink for the game, my legs stopped wobbling.

I don't think I've ever started anything feeling defeated. The instant before I begin, I might be anxious, afraid, but one instant later, when I have something else to get lost in, when it isn't about me, but about *it*, I feel nothing. It's about what happens then that matters. Nothing else. A few hours later, there'd be a winner and loser, but there'd be no winner or loser until then. Nothing that couldn't happen, good or bad.

I don't remember the first period. I remember right after the second period began. A Russian player, I don't know who, had taken a shot, the puck went over the net, hit the taut, fishnet-like netting behind me, and slingshotted back over the net in front. I had known about the netting above the boards—it was so different from the hard glass in our rinks. I knew what could happen, but it hadn't happened until now. I wasn't ready when it did. And because I wasn't, I wasn't ready for the decision I needed to make, instantly: to try to catch the puck coming off the netting, but, facing towards the net, knowing that if I mishandled the puck, it could bounce off my glove and into the net. Or I could let it go. I let it go. The puck went onto a Russian stick in front, and he scored. We were now down, 3–2. It was a big goal at a bad time.

What I remember next was just a lot of weird stuff. The speed of the game picking up, the ferocity, the hits, the slashes,

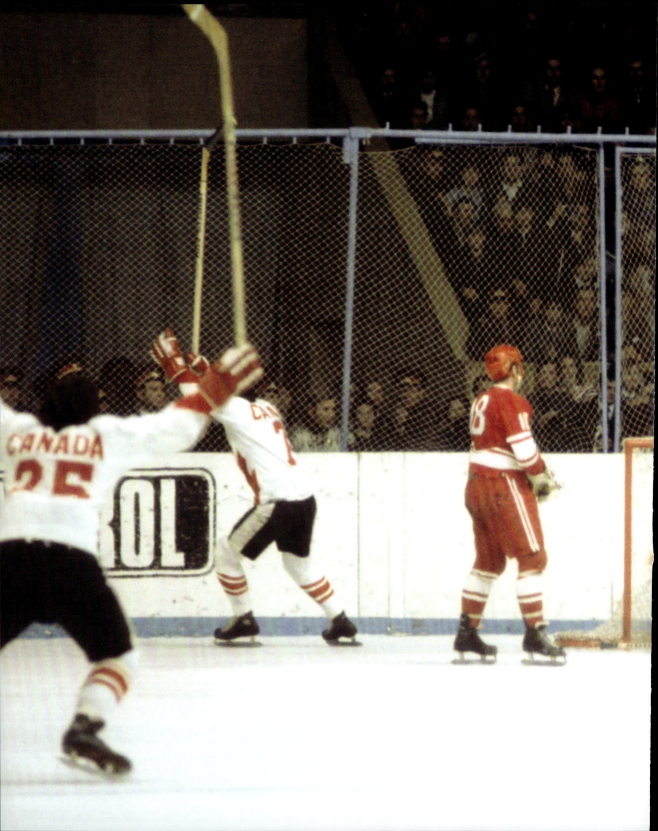

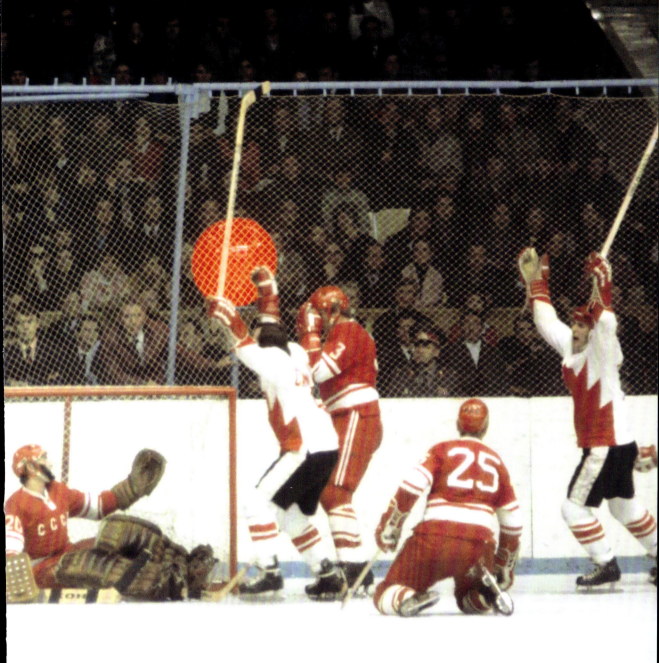

THE DANCE
Game Eight

"Da da Kanada," "Shaibu, shaibu," the urgency of everything. Everything starting to be, on the verge of, finally out of control. J.P. Parisé, a solid, hard-working player, gets a penalty, chases after the referee, draws his stick back as if he's going to take a baseball swing at the referee's head. Then stops. The effect is chilling. He's thrown out of the game. They score twice, we score once, and at the end of the second period, we're down, 5–3.

I remember a calm in the dressing room. Not a quiet, there were surely voices, spurts of yelling and exhorting. Not a confidence, but not a lack of confidence, either. Not a resignation; a simple recognition. There were twenty minutes left. That's it. No more. After all the years of anticipation, after Montreal, Toronto, Winnipeg, and Vancouver, after the ups, crashing downs, and tentative ups again, after all the bad beds, bad elevators, and bad food, it was down to this. Twenty minutes. Harry and John surely said something; others surely did, too. But there was nothing new to hear or know.

We scored early, then scored again, and tied the game. And sometime in the minutes between, the Russians, with the puck near our net, passed it across my crease. I sprawled to make the save, but they passed it back, the net wide open. Then it wasn't. His pride was scoring. In his own defensive zone, he was a fish way, way out of water. Except, suddenly, he was there. He slid. The puck hit him. It was Phil. More weird stuff.

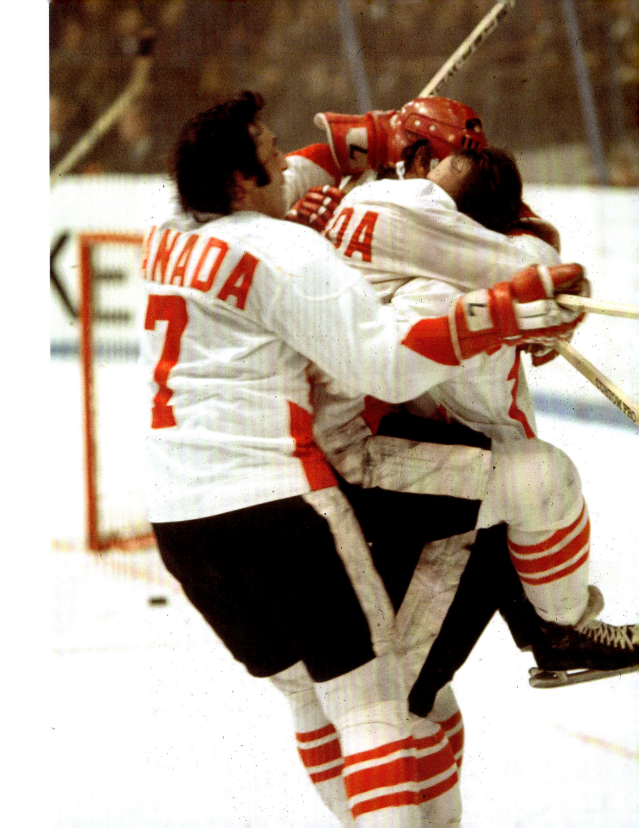

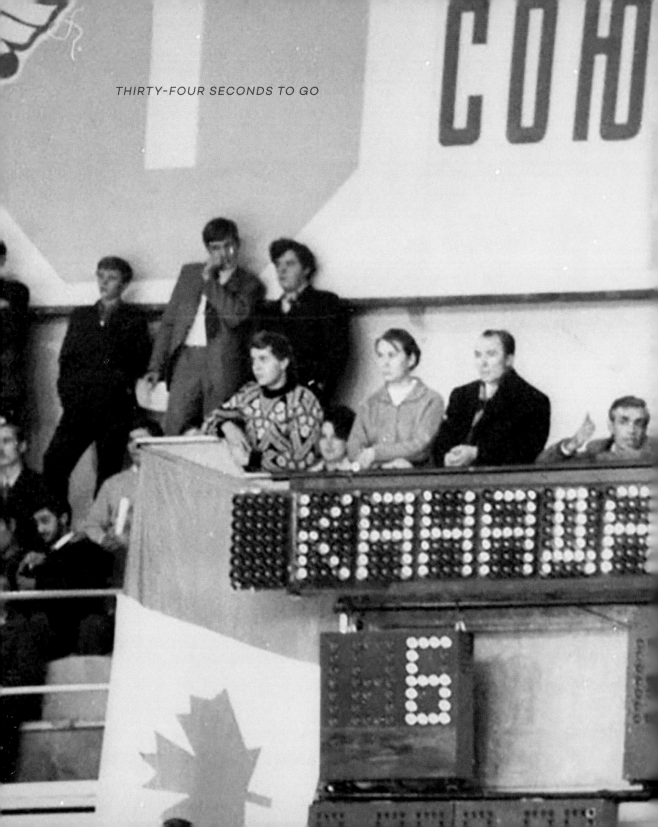

THIRTY-FOUR SECONDS TO GO

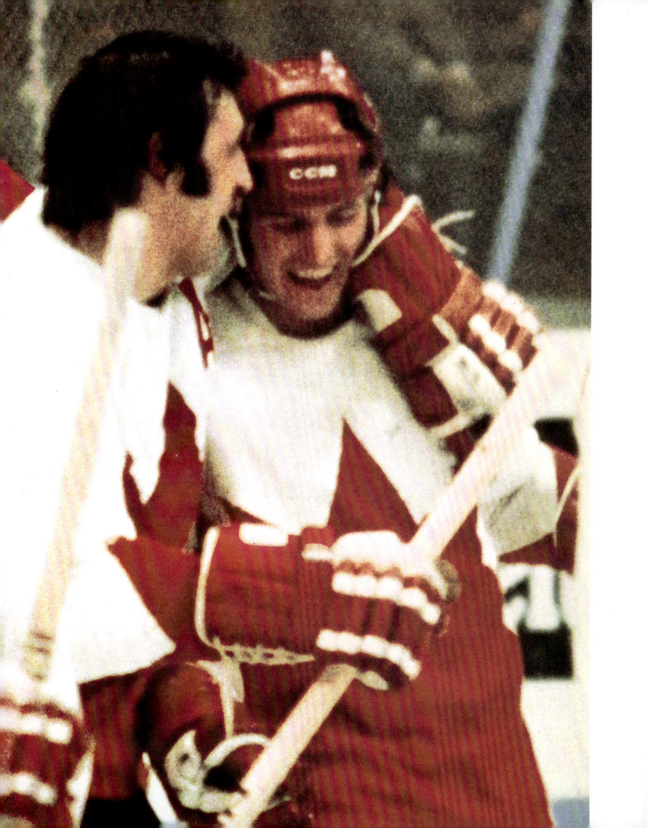

Then the pace, the speed, the urgency, the ferocity, the *da das* and *shaibus*, the out-of-control, and the out-of-control that went even more out of control. Eagleson got into a skirmish with some Russian militia in the crowd, we noticed, he jumped over the boards, the players escorted him across the ice to the safety of the Canadian bench. Everything *more*.

The scream that had begun a few months earlier, which had grown louder, then quieter, then louder again, kept getting louder and louder. Nothing to stop it. Nothing can stop it. No more cheering, no more booing, everything noise.

At a game's end, I know that whoever wins deserves it. Almost always. They've earned it, somehow, some way, and the other guy didn't. What now? Who now?

I don't remember the next few minutes. I don't remember anything until the goal. I don't even remember what led up to the goal. I just remember someone banging at the puck, I didn't know it was Henderson, then a pause—I couldn't see the puck, I didn't know where it was—then I remember the red light, or Henderson's stick in the air, I don't know which came first, then other sticks in the air, then my own stick in the air. Then I remember being at centre ice, I don't know how I got there, I remember hearing the *clomp clomp clomp* of my goalie skates on the ice, my whoops and hollers. Then I remember the scrum

Москва. Спасская башня Кремля
и храм Василия Блаженного.
Фото А. Рязанцева.

Sept 29/72

Hi GANG!
FROM RUSSIA
 WITH LOVE!
 — We WON!
 What a party!
 — John P.

экзм. СССР. Л 49185 18/V 1972. МПФ. Зак. 17583. Цена 4 коп.

Куда STAFF
 LORD's PHARMACY
 206 THIRD AVE
Кому TIMMINS, ONTARIO
 CANADA ,

Индекс предприятия связи и адрес
отправителя: Go. Go! CANADA !

of hugs around Henderson. Then I remember my own sudden slap-myself-in-the-face moment, thinking, *There's still 34 seconds to go!*

After that, nothing, until, with only a few seconds left, a long shot coming towards me from outside the blue line that was going wide, surely it was going wide—*Don't try to catch it, don't let it deflect off your glove into the net*—and letting it go. Then the buzzer, horn, light, I don't know, it was over.

I remember the yelling and shouting in the dressing room, the hugs, the way it is when every championship is won. Then I remember it being less loud than I expected. Still some hugging, still the big smiles, but more players sitting, more a little by themselves, into themselves. It was almost quiet. It was still celebration, deep, deep celebration. But more than that, like the feeling of being shot at and missed, it was deep, deep relief.

The scream had stopped.

PART TWO

OVERTIME

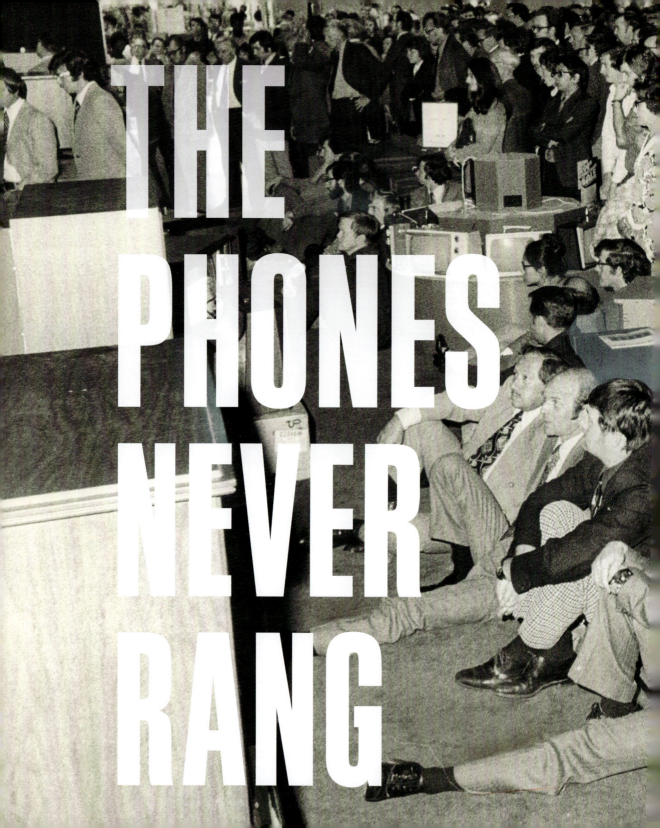

THE PHONES NEVER RANG

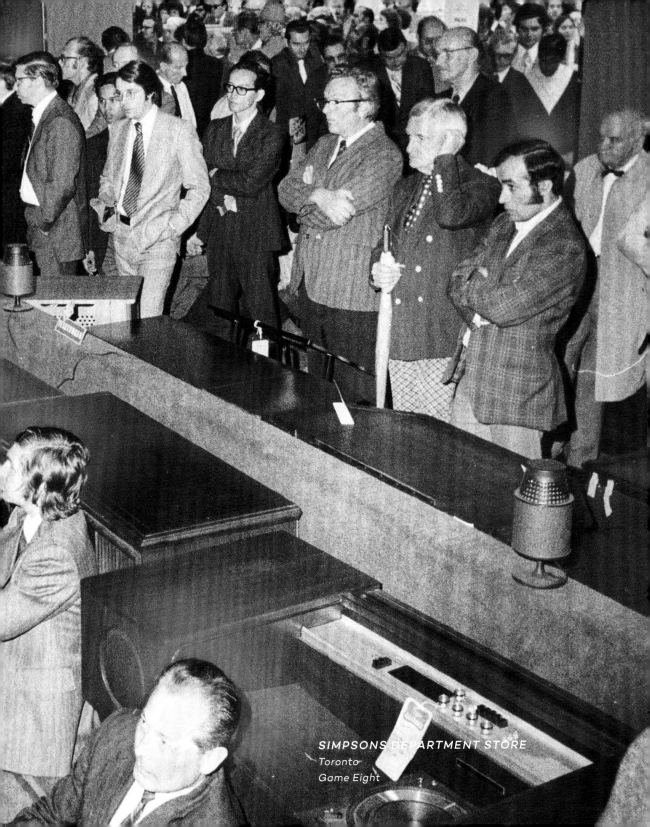

SIMPSONS DEPARTMENT STORE
Toronto
Game Eight

BUT NOT QUITE.

It is now ten months later. One of the TV networks is rerunning the series, one game a week on Sunday afternoons through the summer. I think, *Fantastic!* All that thinking and doing and not feeling is over. We won. It's done. Now I can sit back and just love it.

I set myself up in my favourite chair, an ice cube–filled glass of Coke beside me, and turn on the game. I see us score, I may see us score the second goal, but this isn't fun. I know what is coming next, I know what I'm going to feel. I turn off the TV and leave.

Sixteen years later, I'm doing a documentary for CBC called *Home Game.* One of the six hours, about Canada in the world, focuses on the 1972 series. To write the narration, I know I have to watch it. So, I do, like a researcher, as if I'm examining a specimen in front of me, not getting too close, sort of watching and sort of not. I haven't watched it since.

PROGRAMME OFFICIEL DE TÉLÉDIFFUSSION
de la série de Moscou
du 22 au 28 septembre 1972

OFFICIAL HOME TV PROGRAM
For the Moscow Series
September 22-28, 1972

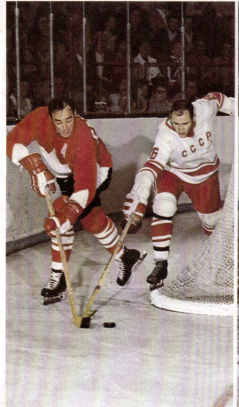
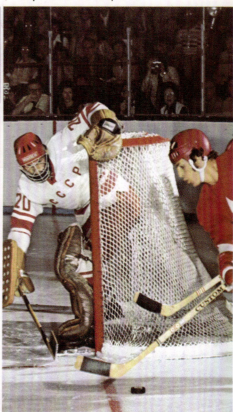

PRÉSENTÉ EN COLLABORATION AVEC
PRESENTED IN ASSOCIATION WITH

I tell people I don't watch because, over time, without my own prodding, the series has come to matter to me a lot. I have more of a stake in it now than I ever had before. I don't want anyone else's take on it, book or film. I don't want the feeling I have to be muddied, confused, put at risk. My memory of Phil Esposito in 1972 is what Phil Esposito was like in 1972. To me. My memory of Paul Henderson, Pat Stapleton, Bobby Clarke, Pete Mahovlich, Harry Sinden, of the team itself, the same. I've learned to tell people this because it's true, and because I've learned it's something they understand and accept.

I also tell them, jokingly, but not entirely, that I don't watch because if I *do*, maybe this time it will turn out differently.

I sometimes do think about how it would be if it had turned out differently. If we had lost Game Eight. If we had lost the series. All that vitriol from Vancouver and ten times more would have come back at us. Fingers would be pointed. I might have been history's goat. Some people can handle humiliation, they can laugh it off, ignore it, act as if it didn't happen. I'm not good at that. I think, when something really bad happens to me, that everybody I meet knows and can think of nothing else. After the series, I was part of five Stanley Cup champion-ships in Montreal. I'm not sure that things would have turned out the same way for me if we'd lost.

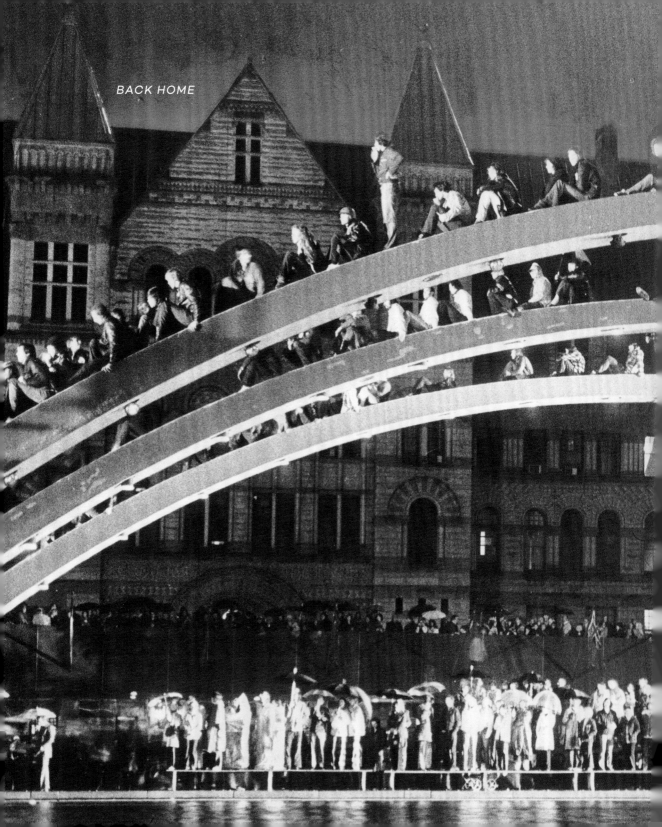

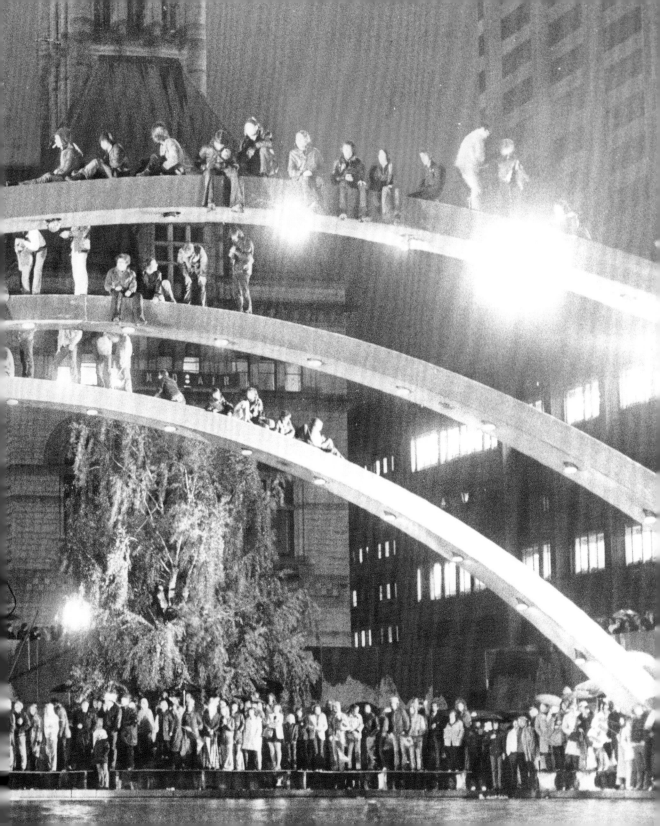

TWO TYPICAL RUSSIAN
HOCKEY FANS.

(DEUX PARTISANS TYPIQUES DES RUSSES).

TWO TYPICAL CANADIAN
HOCKEY FANS.

(DEUX PARTISANS TYPIQUES DU CANADA).

But we won, and I don't look back, except at special moments like this. It's over. Get on with it. I do have one, what might seem odd, regret. As much as I loved being on that team, I missed watching us play. I missed being in Canada, in some big city or small town, with family, friends, co-workers, riding the series' incredible ups and downs, the arguments we'd have, the stupid theories, the dumb-serious, destiny-altering superstitions we'd create, seeing the Esposito speech, Esposito like Pavarotti, Henderson the incredible hero, loving us, hating us, loving us.

It's such an overwhelming feeling when your hometown team goes on a run in the Stanley Cup playoffs. People who don't care about hockey, but love being with other people, suddenly sharing something, believing in something together. It takes them over, fills their days and nights. But, in Canada, in a Stanley Cup final, where there might be only one Canadian team, at most, the fans of the other six Canadian teams don't exactly jump on your bandwagon. But in 1972, one Canadian team. No divided loyalties. One feeling. Everywhere.

To this day, people over fifty-five still remember where they were when Henderson scored. The final game was on a Thursday, 8 p.m. Moscow time, 1:30 p.m. in St. John's, 1 p.m. in Halifax, noon in Montreal, Toronto, and Frobisher Bay (Iqaluit), 11 a.m. in Winnipeg, 10 a.m. in Calgary and Edmonton,

9 a.m. in Vancouver, Victoria, and Whitehorse. In small towns, in villages, in cabins miles away from anything else, all across the country, they watched. This, during *work hours* and *school hours*. Canada's population in 1972, every man, woman, and child, aged zero to over one hundred: twenty-two million. The number who watched that day: sixteen million. No other moment in Canadian history has been so shared—not Vimy Ridge, not D-Day—not before that time, not ever. But more than shared, Canadians were a *part* of it. For twenty-seven days, almost the entire month of September—not a two-week Stanley Cup final, not a one-game sudden-death gold medal game—they shared the shocking downs, the hopeful ups, the crashing downs, the crushing downs, the tentative ups, the less tentative ups, then the *maybe* . . . then finally the *needs to be*, the *has to be*. *This is it*. And people watching not in ones or twos, but as families, as co-workers, as classmates. Watching together. TVs were brought into school gyms. Into offices and stores. Life stopped.

Later, a guy who worked for the power company in rural Saskatchewan told me that on that day, he knew better than anything he had known in his whole life that the power could not, *must* not, go out. Game Eight pressure. Another guy I know worked for a big moving company. His managers handled hundreds of calls an hour. That day, they found a TV they were supposed to deliver, brought it out, and watched.

Nobody was there to answer the phones. But the phones, he said, never rang.

Story after story. I've been in groups where people were asked, "Where were you?" And one by one, they answered, rediscovering a story, becoming more emotional as they did. Sometimes, when the question came back around to me, forgetting, someone would ask me the same question. "One hundred eighty feet away," I'd tell them. They'd say how amazing it must have been, being there, on that same ice surface. I'd tell them it was, but I also told them how amazing it must have been being here, where they were.

I would have loved that.

HAMILTON
Construction Workers
Game Eight

IT'S WHY I'M HERE

HOCKEY CHANGED AFTER THE SERIES.

But it took a while. I think we all needed a break. But we couldn't not see what we saw, we couldn't not know what we learned. The Russians were good. And they'd become good having gone down a very different path. They had trained off ice because they didn't have much indoor ice. They trained more months of the year because they'd started so many years behind us, and because their political system could demand it. They passed the puck more because their sporting history was dominated by soccer and bandy, like field hockey on ice, sports played on big surfaces with wide-open spaces. They made the player with the puck less important than the others because that's the way it was in soccer and bandy, and because that player was only one and the others were four.

It was college coaches in both Canada and the U.S. who were the first to change, but college hockey coaches in both countries didn't matter much then. The only coaches who did were in the NHL, and back then, only a few of the best, Scotty Bowman

and Fred Shero of the Flyers included, were even curious. In the 1970s, it seemed, you had to be an "NHL guy," in which case you had to trash the European game, or a "European guy" and trash the NHL. It was still Cold War stuff—us versus them. It didn't matter whether the question was politics, economic philosophies, or hockey. It was about patriotism, jingoism, old, historic arguments, your system and way of life versus mine. A few European players arrived in the NHL that decade—most notably, Börje Salming of the Leafs; later, a few more Swedes; in the 1980s, some Finns and Czechoslovaks as well; but with the Iron Curtain still in place, not any Russians.

The real change began with Wayne Gretzky, who, at eleven years old, watched the series at home in Brantford, Ontario. He, too, came to play an open-ice game; he, too, was a passer; he, too, understood that five players moving forward was better than one. And Gretzky being so good, his Oilers team-mates followed. We might have thought of this style of play as "Gretzky hockey" or "Oilers hockey," but it began with the Russians and the 1972 series. So, when the Wall came down and the Russians began to arrive in numbers in the 1990s, they arrived into a game that was ready for them, that could bring out the best in them.

Once it was clear just how good the Russians were—in the NHL— the rest has followed: more off-ice training, more off-ice training

specialists, more on-ice coaching specialists, more hours of the day, more months of the year, not because a governmental system demands it, but because an economic system—bigger contracts—encourages it. More science entered the NHL game as well. And once there's more science, more fields of study join the action—nutrition, kinesiology, psychology—more research, more learning, universities, labs, anywhere, everywhere, anything, everything, whatever might give you an edge. One thing leading to another and another, all of it winding its way back to the 1972 series.

The Russians were changed, too. The whistles that berated us in Luzhniki Arena were the result of real anger in the Russian fans—they loved their team—but, after dealing with the shock of seeing our "rude" play the first time, there was also something in our game that the Russians admired. The way we always played to the end, always believed, never gave in. Even the hardness of our game. Even our roughness. Russia is a tough winter country, too. Wayne Gretzky, unlike any Canadian player in 1972, played like a Russian. Alex Ovechkin now, unlike any Russian player in 1972, plays like a Canadian. And who is the best-known Canadian player in Russia today? Probably Gretzky. But, after him, maybe even better known in Russia now than he is in Canada (except as the guy who made The Speech): Phil Esposito.

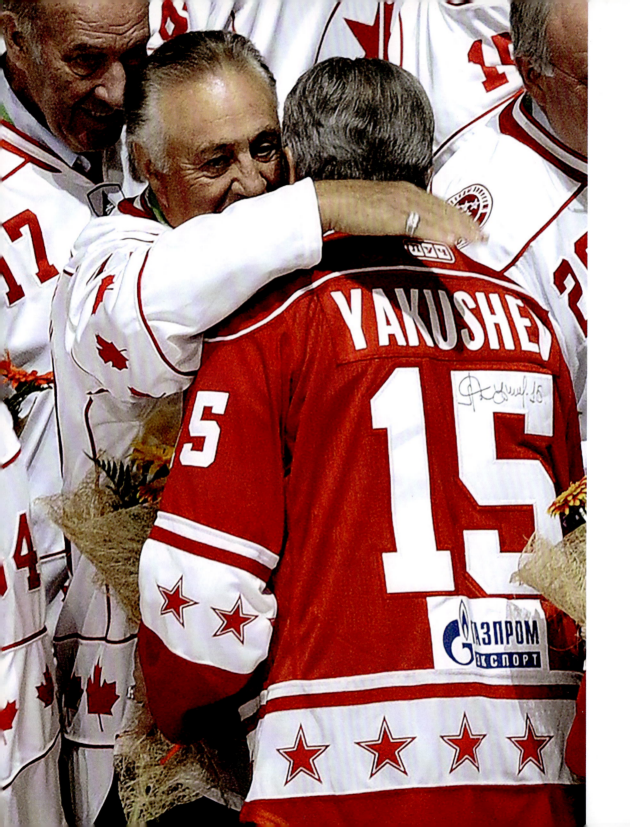

And if Canada's and Russia's hockey could be changed, so could hockey's future everywhere else. In Canada, the focus had been on competition. On games. Each one a contest of will and strategy, played at the highest level, demanding ever-higher will, ever-more-intriguing strategy. It's why an NHL that had only six teams in the mid-1960s, each team playing the other fourteen times a year, year after year, Montreal against Toronto, Toronto against Montreal, could work. It's why, in world hockey for all those decades, with no one else good enough to compete, it could be just Canada.

But, by shifting hockey's focus from games to skills as the Russians did, as they showed in this series, everything can be different. Games need an opponent, but skills can be developed anywhere. In any backyard rink or gym, in Alberta, Azerbaijan, or Arizona. The NHL might have opened up hockey by expanding geographically to most of North America. But what truly opened up hockey was when the NHL, Canada, and the world all realized that this game can be played, at the top, differently, with different skills, by anyone. *That*, more than anything, more than us as Canadians showing our magisterial superiority to the world, is the legacy of this series. By us, Canada, losing a little, hockey—and, ultimately, Canada—won a lot.

One more legacy. One of my favourite figures in history is Ernest Shackleton. After he lost the race to the South Pole in the early 1900s, Shackleton set out to be the first to cross Antarctica by way of the Pole. But his ship got stuck in the ice, was crushed, and sank. With no radio communication, he and his crew set off in lifeboats, into the open ocean, looking for land. Finding land, but finding it inhospitable, he and a few others then set out in a single boat, at the mercy of ocean currents and ocean storms. What they were looking for was not much bigger than a needle in a very large haystack. And they found it: South Georgia Island. Then, more than nineteen months after they'd been stuck in the ice, more than nine months after their ship had sunk, after travelling more than three thousand kilometres in open waters—all this time with no communication with the outside world—Shackleton, in his lifeboat, returned to rescue the men who had been left behind. Every one of the twenty-two was still alive.

We didn't learn much about Shackleton in school. We learned about Amundsen. He made it. Shackleton didn't; he failed. He failed at the task that history rewards. But the past is more than events. More than facts. It is stories. And Shackleton's story is by far the more amazing, and today, by far the more remembered. He failed in what he set out to do, and succeeded to a far greater dimension in a way he never imagined.

Before the series began, Canada wanted to win all eight games; it *had* to win the series. Russia wanted to win the series; it *had* to show it could compete *at the top*. Neither of us got what we wanted; both of us got what we needed. Both of us succeeded in a way, and to a dimension, we never imagined. Like Shackleton. This may be the only series ever where the loser looks back on it almost as fondly as the winner.

When great new moments happen, when great young players come along, we feel the need to compare. Over time. Through history. But it's hard, and we often get it wrong because some moments and players are fresh in memory, and some are not. Sometimes, memory makes us better than we were; sometimes, freshness makes us better than we are. Then a few years pass and most of these GOAT—greatest of all time—moments, players, and teams seem to fade into a pack of mere greats, and only a very few still stick out. We like to think that we can argue and persuade and orchestrate our way to the judgment we want, to the one we decide, but we don't, and we can't. History decides. Somehow, it gathers together what is great, and significant, and unique, and makes its judgment.

It's the same with our own memories. So much fades away; in time, only a very few still linger and shine. In my hockey life, I was on one NCAA championship team and several Stanley Cup–winning teams. I was an important member of many of those teams.

THE ENEMY, MY FRIEND
Yaroslavl, Russia, 2012
Ken Dryden, Vladislav Tretiak

Other Team Canada players won lots of championships—as kids, in junior, and in the NHL. The Russian players won many world championships and Olympic gold medals. But somehow, for me—and, I think, for almost all the players on *both* teams—this series means the most to them. I was just another player, as almost all of us were. I wasn't Esposito or Henderson, just as the Russian players weren't Yakushev or Kharlamov. I didn't play the way I wanted to, but all these years later, I'm a little proud of myself. I hung in there. Sometimes, that is the hardest achievement.

Memory is odd. We have so many recollections inside us. How do we understand them? How do they all fit together? What is the story? The *real* story? In 1972, there were all kinds of possible stories. If the series had ended after four games, or five, if the Russians hadn't taken their foot off the gas in Game Six. If, at the end, Foster Hewitt's words hadn't been "Henderson has scored for Canada," but "Tretiak makes the save for Russia . . ."—it was a hard but stoppable shot—then all those details in all those games suddenly would've been pieced together differently. Different ending. Different story.

So, after fifty years, what *is* the story? One of fate and chance and great deeds, Henderson's story? One of never-say-die Canadians, Esposito's story? One that is amazing as fact? One that grows in the telling? Maybe both together? Is it a Cold

War story? Hockey, like the space race, a stand-in for the real thing? Canada playing its own small role, the only one a small country can play? Maybe that Canada's was a different kind of Cold War story, one where, by crossing borders and seeing each other up close, we came to respect, not just hate, opening the door, someday, to a cold peace, not just a cold war? Or maybe, really, the story is what twenty-two million Canadians and 245 million Soviets then, thirty-eight million Canadians and 145 million Russians today, make it to be.

And also, for the players on both teams, what it has come to be for us. Not just our favourite hockey memory, but after fifty years, what we feel about each other. Then, they were *the other guy*. The hated other guy who was doing *everything* to stop us from doing what we had to do. Who made the country boo us and made us feel like crap. Who made us fight back, commit and commit, and caused us so much pain. But who also made us find in ourselves something we didn't know was there. Who left us with a lifetime memory that is more penetrating, more fulfilling than any other we have. The Yankees and Red Sox, Celtics and Lakers, Ali and Frazier—they hated each other. They needed each other. They defined each other. They made each other better. Everybody needs a great opponent. The series began as Us and Them. Fifty years later, it's *Us*. Allies again.

22-IX-1972 СССР МОСКВА ДВОРЕЦ СПОРТА ИМ. В.И. ЛЕНИНА (МАТ

СБОРНАЯ
СССР

СБОРНАЯ
КАНАДЫ

Н	ХАРЛАМОВ	✓	УДАР ПО РУКАМ	2		Н	ЭЛЛИС	✓	ПОДНОЖКА
Н	ХАРЛАМОВ	✓	ОБОЮДН. ГРУБОСТЬ	2		Н	ЭЛЛИС	✓	ОБОЮДН. ГРУБОСТЬ
Н	БЛИНОВ	✓	ПОДНОЖКА	2		Н	БЕРГМАН	✓	УДАР РУКОЙ
Н	ЦЫГАНКОВ	✓	ОБОЮДН. ГРУБОСТЬ	2		Н	УАЙТ	✓	ТОЛЧОК НА БОРТ
Н	ЯКУШЕВ	✓	ПОДНОЖКА	2		И	КЛАРК	✓	ОБОЮДН. ГРУБОСТЬ

0 1

0 3

5 4

16 МИН.	ТРЕТЬЯК	0	1	ПАРИЗЕ (ПЕРРО)
23 МИН.	ТРЕТЬЯК	0	2	КЛАРК (ХЕНДЕРСОН)
32 МИН	ТРЕТЬЯК	0	3	ХЕНДЕРСОН (КЛАРК)
44 МИН	БЛИНОВ (ПЕТРОВ)	1	3	Т. ЭСПОЗИТО
46 МИН.	ТРЕТЬЯК	1	4	ХЕНДЕРСОН (КЛАРК)
49 МИН.	АНИСИН (ЛЯПКИН)	2	4	Т. ЭСПОЗИТО
49 МИН.	ШАДРИН	3	4	Т. ЭСПОЗИТО
52 МИН	ГУСЕВ (РАГУЛИН)	4	4	Т. ЭСПОЗИТО
55 МИН.	ВИКУЛОВ	5	4	Т. ЭСПОЗИТО

ЛУЧШИЕ ИГРОКИ, ОПРЕДЕЛЁННЫЕ ЖЮРИ:

ТОНИ ЭСПОЗИТО ПОЛ ХЕНДЕРСОН (ОБА-КАНАДА)

АЛЕКСАНДР ЯКУШЕВ ВЛАДИМИР ПЕТРОВ (ОБА-СССР)

СУДЬИ: №14 -УДАЛЬБЕРГ (ШВЕЦИЯ)

№15 -Р.БАТА (ЧССР)

I AM WHAT I DREAM, "Я становлюсь тем, кем я мечтаю стать":
Notebook, Igor Kuperman, age 15, Moscow

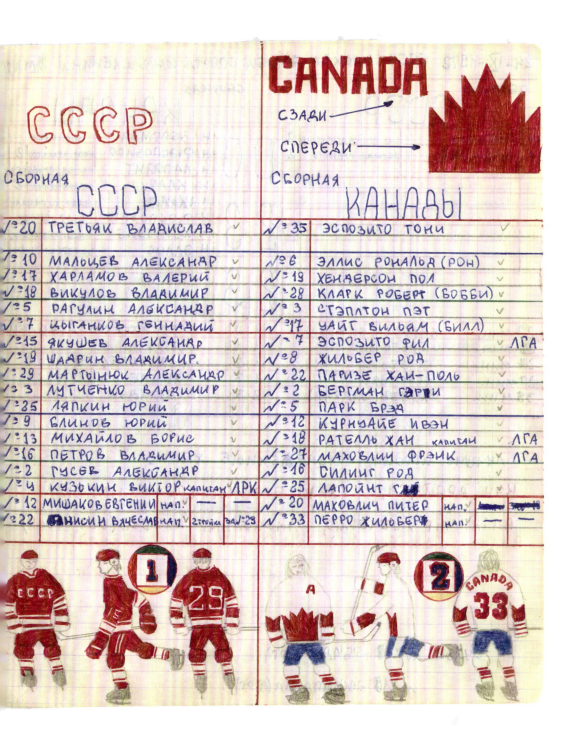

CCCP

CANADA

СЗАДИ →

СПЕРЕДИ →

СБОРНАЯ **СССР**

СБОРНАЯ **КАНАДЫ**

№	СССР			№	КАНАДЫ			
№20	ТРЕТЬЯК ВЛАДИСЛАВ	✓		№35	ЭСПОЗИТО ТОНИ			✓
№10	МАЛЬЦЕВ АЛЕКСАНДР	✓		№6	ЭЛЛИС РОНАЛЬД (РОН)			✓
№17	ХАРЛАМОВ ВАЛЕРИЙ	✓		№19	ХЕНДЕРСОН ПОЛ			✓
№18	ВИКУЛОВ ВЛАДИМИР	✓		№28	КЛАРК РОБЕРТ (БОББИ)			✓
№5	РАГУЛИН АЛЕКСАНДР	✓		№3	СТЭПЛТОН ПЭТ			
№7	ЦЫГАНКОВ ГЕННАДИЙ	✓		№17	УАЙТ ВИЛЬЯМ (БИЛЛ)			
№15	ЯКУШЕВ АЛЕКСАНДР	✓		№7	ЭСПОЗИТО ФИЛ		✓	ЛГА
№19	ШАДРИН ВЛАДИМИР	✓		№8	ЖИЛЬБЕР РОД			✓
№29	МАРТЫНЮК АЛЕКСАНДР	✓		№22	ПАРИЗЕ ЖАН-ПОЛЬ			✓
№3	ЛУТЧЕНКО ВЛАДИМИР	✓		№2	БЕРГМАН ГЭРРИ			✓
№35	ЛЯПКИН ЮРИЙ	✓		№5	ПАРК БРЭД			✓
№9	БЛИНОВ ЮРИЙ	✓		№12	КУРНУАЙЕ ИВЭН			✓
№13	МИХАЙЛОВ БОРИС	✓		№18	РАТЕЛЛЬ ЖАН	КАПИТАН	✓	ЛГА
№16	ПЕТРОВ ВЛАДИМИР	✓		№27	МАХОВЛИЧ ФРЭНК		✓	ЛГА
№2	ГУСЕВ АЛЕКСАНДР	✓		№16	СИЛИНГ РОД			
№4	КУЗЬКИН ВИКТОР	КАПИТАН	ЛРК	№25	ЛАПОЙНТ ГАЙ			
№12	МИШАКОВ ЕВГЕНИЙ	НАП.	—	№20	МАХОВЛИЧ ПИТЕР	НАП.	—	—
№22	АНИСИН ВЯЧЕСЛАВ	НАП.	2 ГОЛА ЗА №29	№33	ПЕРРО ЖИЛЬБЕР	НАП.	—	—

After all this remembering and feeling, I still haven't quite answered why I think the series matters so much for the country and for me.

Maybe it's this. In 1980, I was ABC's colour commentator for the U.S. Olympic hockey team's impossible gold medal win in Lake Placid. Hockey is a secondary sport in the U.S., and yet, for Americans, that victory is one of their favourite all-time sports memories. It was, for them, a true and pure Cold War triumph: our system against their system, the essence of us against the essence of them. Our bunch of college kids against their Big Red Machine. And we, America, won. This was America to them, the America that had tamed the West, that created the world's greatest democracy, the city upon a hill. Faced with the impossible, we, as Americans, do the impossible. To them, 1980 is about American exceptionalism.

As Canadians, we have created, we tell, no similar story about ourselves. The Canadian story that has dominated my life, that I don't believe and refuse to hear, is: "Typically Canadian, eh?" How, as Canadians, faced with the possible, we make it *impossible. How our actors, singers, writers, athletes, finally arriving on the big stage of the world, always fall on our faces. Typically Canadian, eh? Wise, wonderfully self-deprecating, incredibly funny. *Ha ha ha*. So, now it's 1972, and on our own big stage, it's the Canadian story all over again. A series we

could not lose. Then Montreal, then Vancouver, snatching defeat from the jaws of victory. Typically Canadian, eh?

Well, guess what—Toronto, Moscow, Moscow, Esposito, Henderson, Moscow again, down 5–3, tied 5–5, thirty-four seconds to go—not this time!

Maybe that's why the series matters so much. And maybe for another reason.

The Soviet players believed in their team. They were proud of it, they wanted to win for themselves, for each other, for their country, for their way of life, just as we did. But, for us, there was something else. It goes back to those games on radio, to Foster Hewitt, the Penticton Vees, Whitby Dunlops, Belleville McFarlands, and Trail Smoke Eaters, to Father Bauer's national team, to year after year of being the best in the world and, year after year, seeing *them* crowned as world champions. When something is deep inside you like that, you go deeper to protect it. You do more because more is needed, and when that isn't enough, you go deeper still, to where you've never been, to where you find another you that you didn't know was inside you. You "lose it," in all the ways we lose things: some get overwhelmed, some go goony, some rise up and ride the wave wherever it takes them. And when talent is present at this same moment, some lose it in amazing, great,

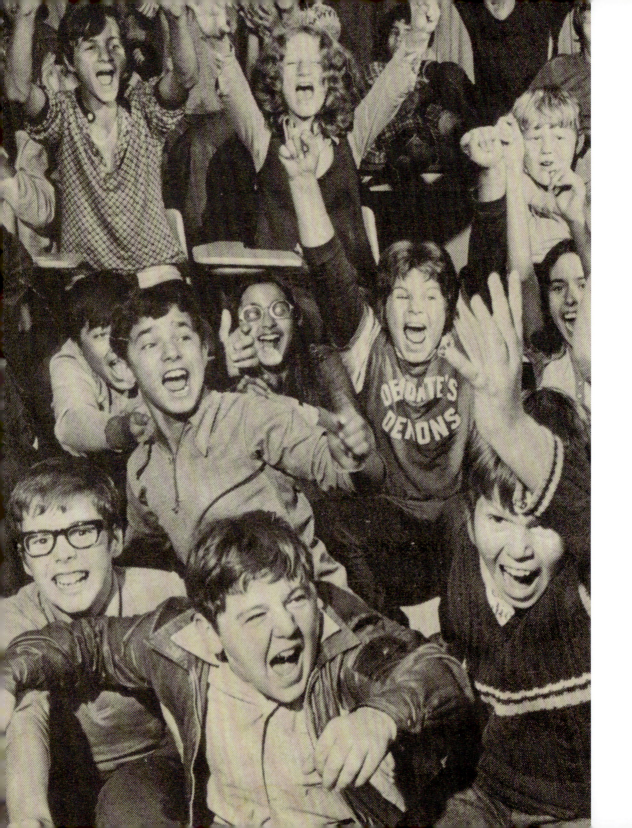

heroic ways. That's why Esposito, not knowing our own end of the ice from a Zamboni, came out of nowhere to save a goal. That's why Henderson, great skater, good all-round player, found the puck go in, and in, and in, not to win one decisive game, not two, but three straight series-changing games. That's why, at certain other moments, the rest of us did what we did.

Historians haven't decided. History has. Canadians have. Other teams, other players in other times, may be better, but the 1972 series is the most important moment in hockey history. And it is one of the most important moments in Canada's history.

Why did we win? Why is the series felt so deeply by players, by fans, by Canadians?

Because it was personal.

ACKNOWLEDGEMENTS

HOW DO YOU TELL A STORY to those who once lived it so deeply that, fifty years later, it's a story that's already their own?

How do you tell a story to those who didn't live it, who weren't yet born, but who have heard it told so often—a story so improbable that it cannot be true?

I want to thank my teammates and coaches on Team Canada, and our opponents, the players and coaches on the Soviet National Team, for making the improbable happen. For writing this story.

Jenny Bradshaw, the book's editor, Joe Lee, who assisted her, Andrew Roberts, the book's designer, and Jared Bland, the publisher at McClelland & Stewart, were not yet born in 1972. I want to thank them for understanding, and for trying to capture and convey in the book's words, its photos, and layout, in every way possible, for all those like them who weren't there, what there was like. For taking on this challenge as if it were personal.

I also want to thank my wife, Lynda, who shared this story in 1972, and through reading and rereading the words on these pages, shared it again.

CREDITS

(Title page, both photographs) Graphic Artists/HHOF Images; (copyright page) Dennis Robinson/*Globe and Mail*; (2-3) Bettmann/Getty Images; (6-7) Michael Sr. Burns/HHOF Images; (12-13) Keystone Press/Alamy Stock Photo; (16-17) Barrie Davis/*Globe and Mail*; (20) Courtesy of Frank Mahovlich; (22-23) Frank Lennon/*Toronto Star*/Getty Images; (24-25) Jeff Goode/*Toronto Star*/Getty Images; (30) Jeff Goode/*Toronto Star*/Getty Images; (32-33) The Canadian Press/Peter Bregg; (34-35) The Canadian Press; (38-39) The Canadian Press/Peter Bregg; (40-41) Melchior DiGiacomo/*Sports Illustrated*/Getty Images; (44-45) Brian Pickell; (46-47) Graphic Artists/HHOF Images; (50) Courtesy of Frank Mahovlich; (54-55) Graphic Artists/HHOF Images; (56-57) Barrie Davis/*Globe and Mail*; (58-59) John D. Hanlon/*Sports Illustrated*/Getty Images; (63) Melchior DiGiacomo/*Sports Illustrated*/Getty Images; (64-65) Dmitryi Donskoy/Sputnik Images; (67) Melchior DiGiacomo/Getty Images Sport Classic; (68-69) Hockey Hall of Fame; (72) Keystone Press/Alamy Stock Photo; (74-75) Hockey Hall of Fame; (76) Courtesy of Team Canada; (80-81) Hockey Hall of Fame; (82) Hockey Hall of Fame; (87) Melchior DiGiacomo/Getty Images Sport Classic; (88) Hockey Hall of Fame; (90-91) Barrie Davis/*Globe and Mail*; (95) Bettmann/Getty Images; (96) Courtesy of the Swedish National Library;

(98-99) Hockey Hall of Fame; (102) Sid Barron/*Toronto Star*; (105) Melchior DiGiacomo/Getty Images Sport; (109, top) Melchior DiGiacomo/*Sports Illustrated*/Getty Images; (109, bottom) Melchior DiGiacomo/Getty Images Sport Classic; (110-111) Frank Lennon/Library and Archives Canada/e010933352; (115) Melchior DiGiacomo/*Sports Illustrated Classic*/Getty Images; (119) Brian Pickell; (120-121) Melchior DiGiacomo/Getty Images Sport Classic; (122-123) Frank Lennon/Library and Archives Canada/e010933351; (126-127) Hockey Hall of Fame; (130-131) Melchior DiGiacomo/Getty Images Sport; (132-133) Hockey Hall of Fame; (134-135) Melchior DiGiacomo/Getty Images Sport Classic; (142-143) Melchior DiGiacomo/*Sports Illustrated*/Getty Images; (145) Melchior DiGiacomo/Getty Images Sport Classic; (146-147) Frank Lennon/Library and Archives Canada/e010933343; (148) Brian Pickell; (150) Hockey Hall of Fame; (154-155) Ron Bull/*Toronto Star*/Getty Images; (158) Hockey Hall of Fame; (160-161) Boris Spremo/ *Toronto Star*/Getty Images; (162) Courtesy of Aislin; (166-167) *Hamilton Spectator*; (168-169) Jeff Goode/*Toronto Star*/ Getty Images; (174) KHL Photo Agency/Getty Images Sport; (178-179) Scott MacPherson; (182-183) Courtesy of Igor Kuperman; (186) John McNeill/Courtesy of the Archives of Ontario/F 4704-1-0-7210.